喬漢娜・貝斯福 著

Johanna Basford

奇幻叢林

Magical Jungle

An Inky Expedition & Coloring Book

遠流出版公司

奇幻叢林
Magical Jungle：An Inky Expedition & Coloring Book

作者 喬漢娜‧貝斯福（Johanna Basford）
譯者 吳琪仁
總編輯 汪若蘭
編輯協力 陳思穎
版面構成 張凱揚
封面設計 張凱揚
行銷企畫 李雙如

發行人 王榮文
出版發行 遠流出版事業股份有限公司
地址 臺北市南昌路2段81號6樓
客服電話 02-2392-6899
傳真 02-2392-6658
郵撥 0189456-1
著作權顧問 蕭雄淋律師

2016年9月1日 初版一刷

定價 新台幣280元（如有缺頁或破損，請寄回更換）
有著作權‧侵害必究
ISBN 978-957-32-7865-8

遠流博識網 http://www.ylib.com E-mail: ylib@ylib.com

預行編目
國家圖書館出版品預行編目(CIP)資料

奇幻叢林 / 喬漢娜.貝斯福(Johanna Basford)著 ;
吳琪仁譯. -- 初版. -- 臺北市：遠流、2016.09
　　面；　公分
譯自 : Magical jungle : an inky expedition & colouring book
ISBN 978-957-32-7865-8(平裝)

1.繪畫 2.畫冊
947.39　　　　　　105012578

這本書是屬於

· ·

Johanna Basford

Hidden inside this book are . . .

這本書裡頭藏有……

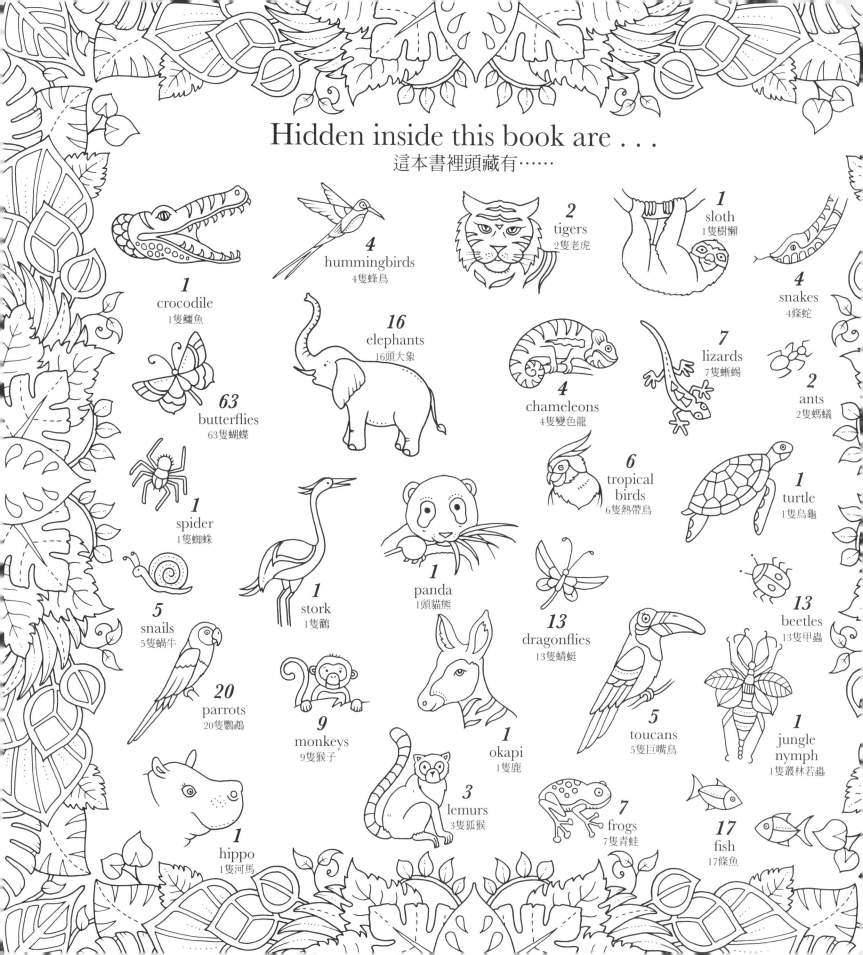

1 crocodile
1隻鱷魚

4 hummingbirds
4隻蜂鳥

2 tigers
2隻老虎

1 sloth
1隻樹懶

4 snakes
4條蛇

63 butterflies
63隻蝴蝶

16 elephants
16頭大象

4 chameleons
4隻變色龍

7 lizards
7隻蜥蜴

2 ants
2隻螞蟻

1 spider
1隻蜘蛛

6 tropical birds
6隻熱帶鳥

1 turtle
1隻烏龜

5 snails
5隻蝸牛

1 stork
1隻鶴

1 panda
1頭貓熊

13 dragonflies
13隻蜻蜓

13 beetles
13隻甲蟲

20 parrots
20隻鸚鵡

9 monkeys
9隻猴子

1 okapi
1隻鹿

5 toucans
5隻巨嘴鳥

1 jungle nymph
1隻叢林若蟲

3 lemurs
3隻狐猴

7 frogs
7隻青蛙

17 fish
17條魚

1 hippo
1隻河馬

前言

請拿起色筆，塗上各種色彩，讓本書裡的動植物充滿生氣，
也讓你的想像力與創意無限奔馳！
不論是熱帶的鳥兒、珍貴的蘭花、奇特的變色龍、古靈精怪的非洲鹿，
在這個蒼翠繁茂的雨林裡，
充滿了各種野生動植物，也提供了各種色彩繽紛的創作靈感。

這裡有非常多不同的生物，大的小的都有，全藏在樹叢裡，你可以全部都找出來嗎？

著色小訣竅

☑ 請使用本書最後面的試色頁面，用筆畫在上面試試看顏色如何。

☑ 鉛筆其實也可以用來著色，而且可以跟其他顏色混合一起畫。

☑ 色筆可以畫出明亮鮮豔的顏色，但不要畫得太用力，而且記得下筆前請先試畫一下。

☑ 不要害怕畫到線外面。

☑ 跟朋友們分享你的作品，或是分享在社群媒體，大方秀出你的傑作！

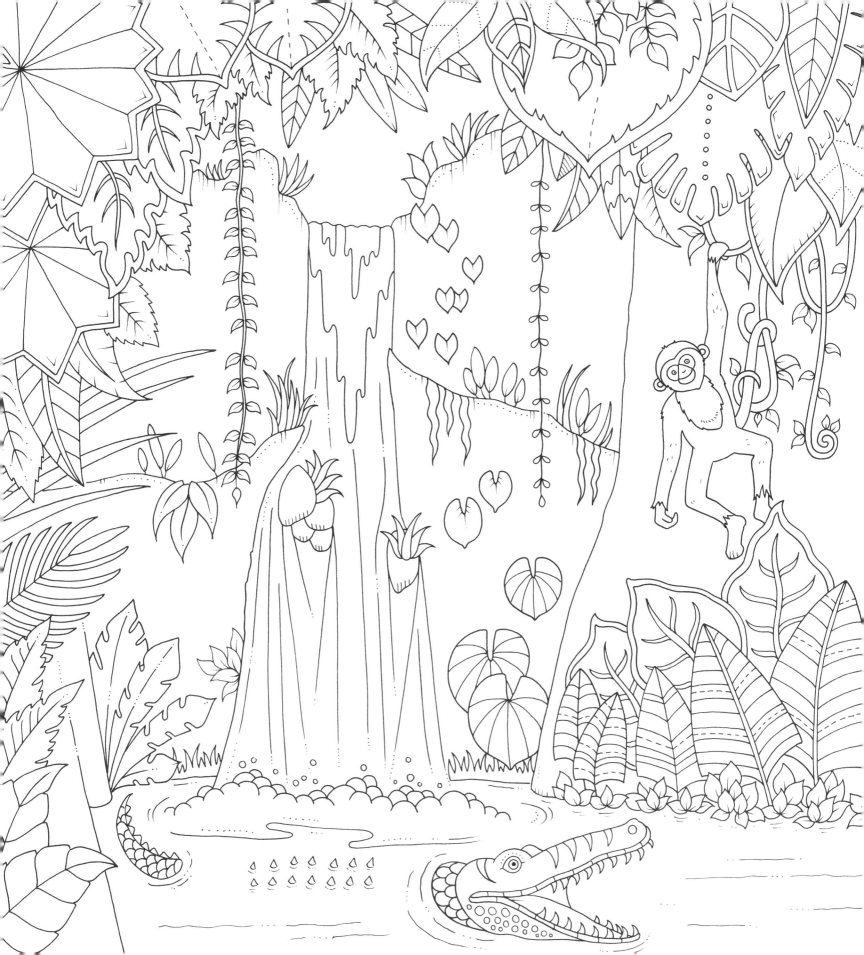

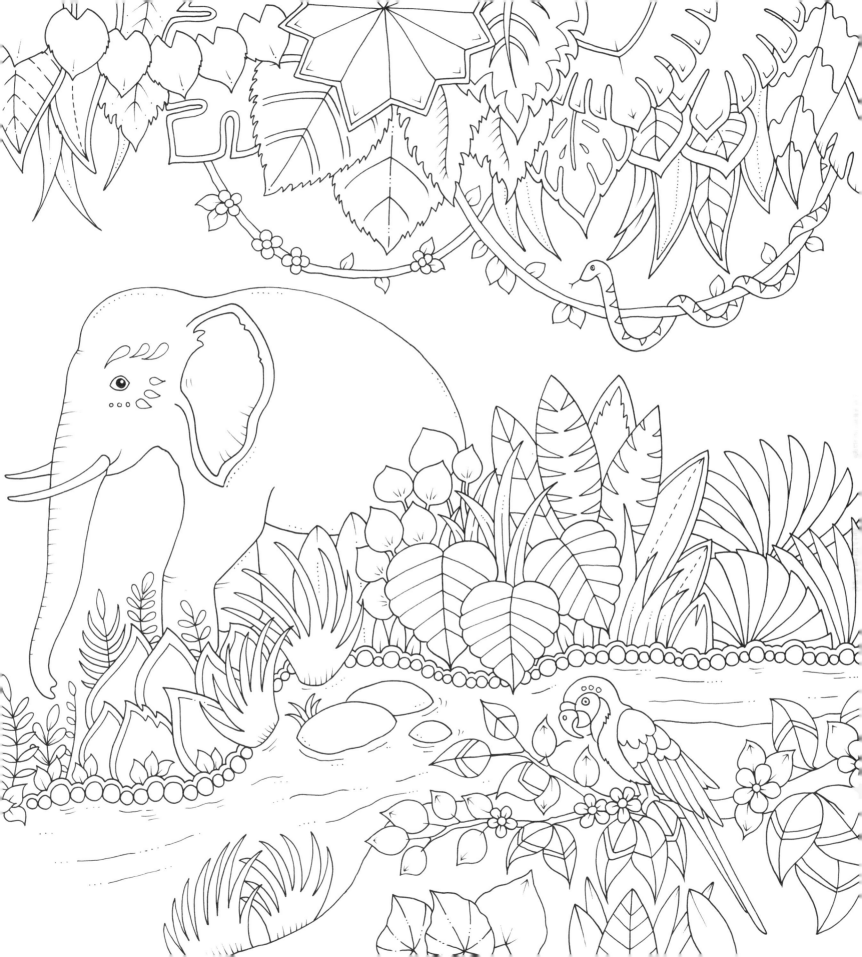

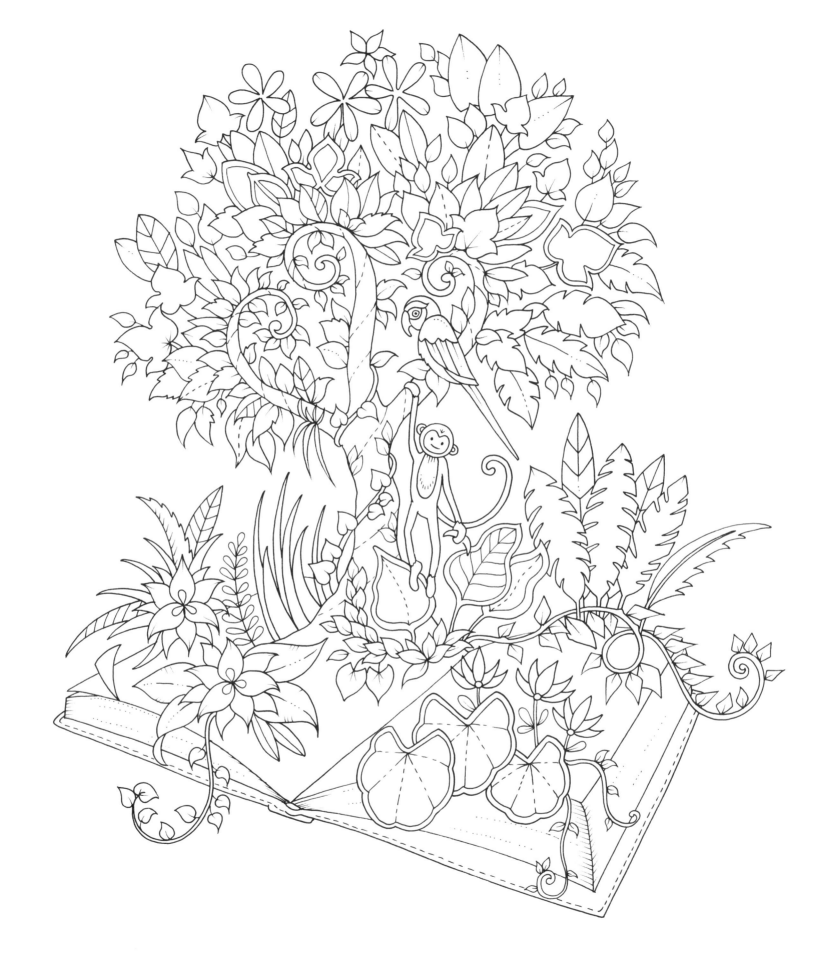

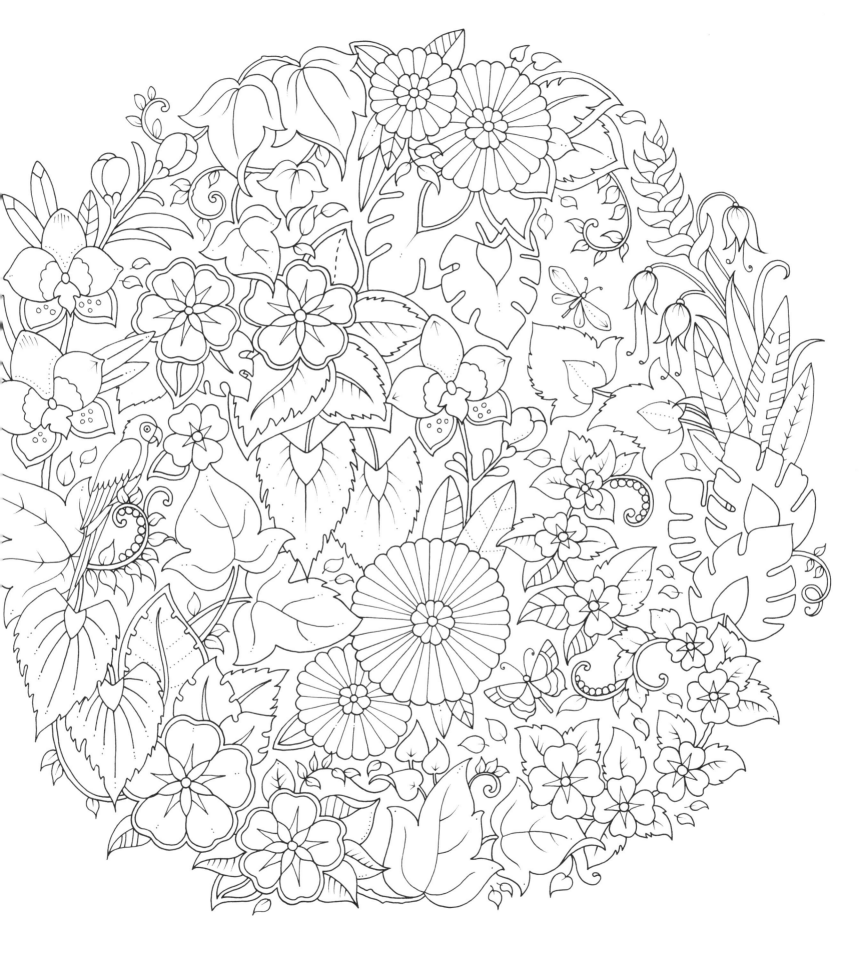

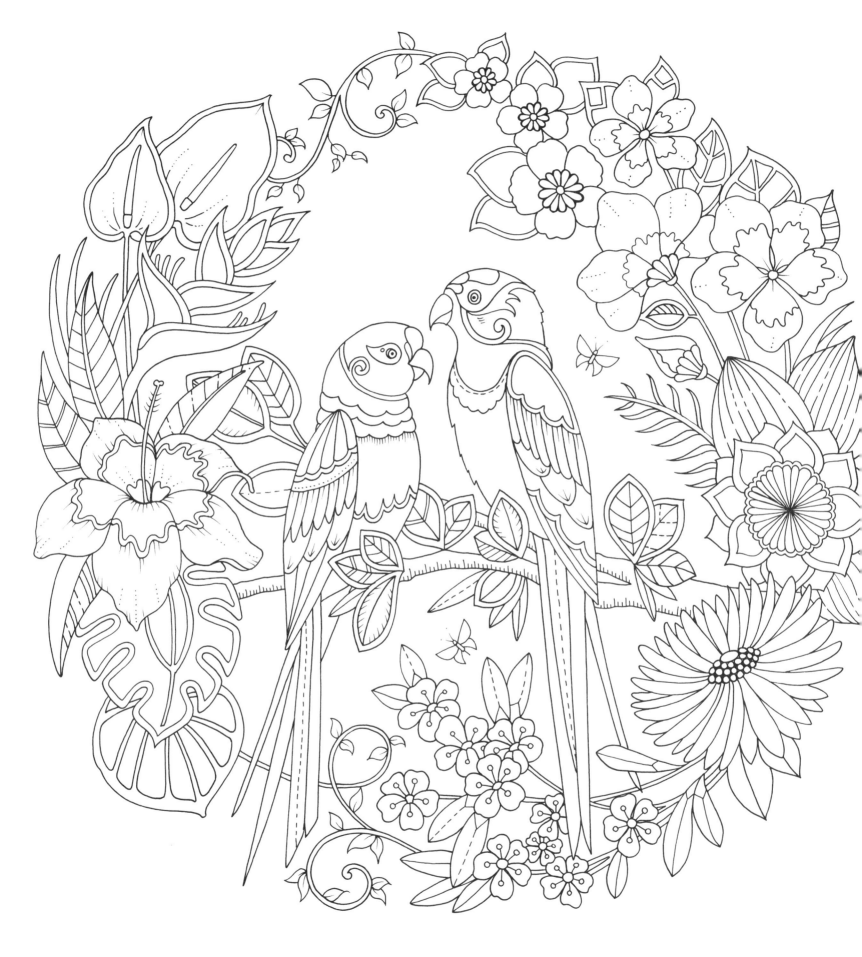

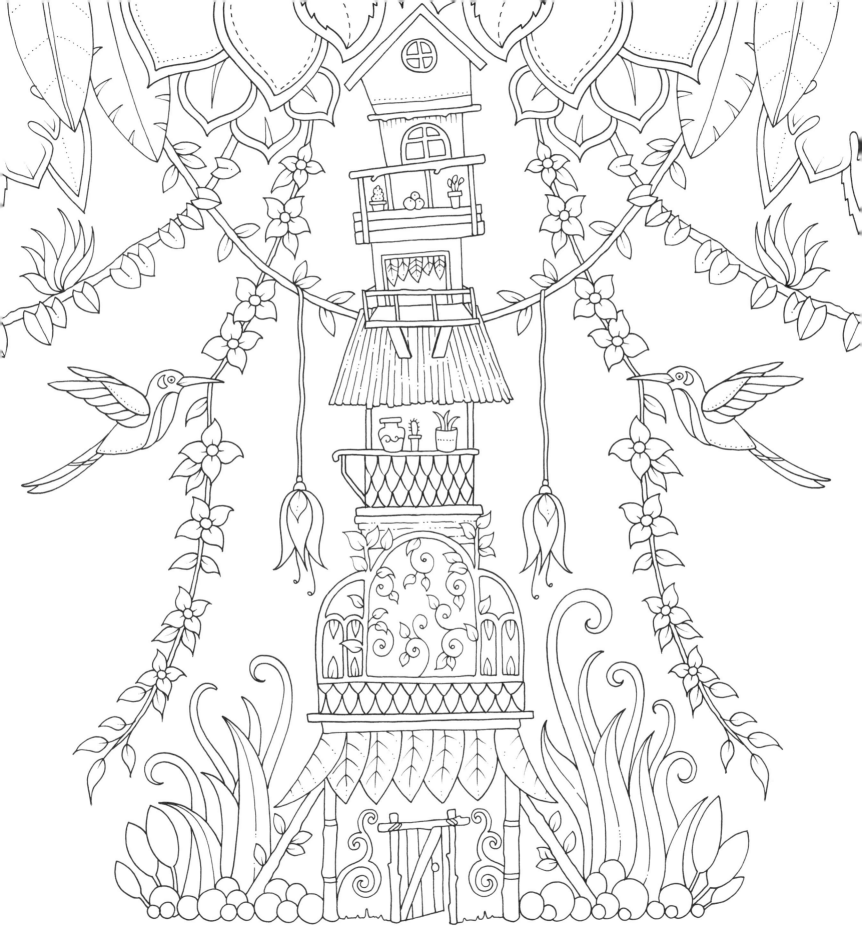

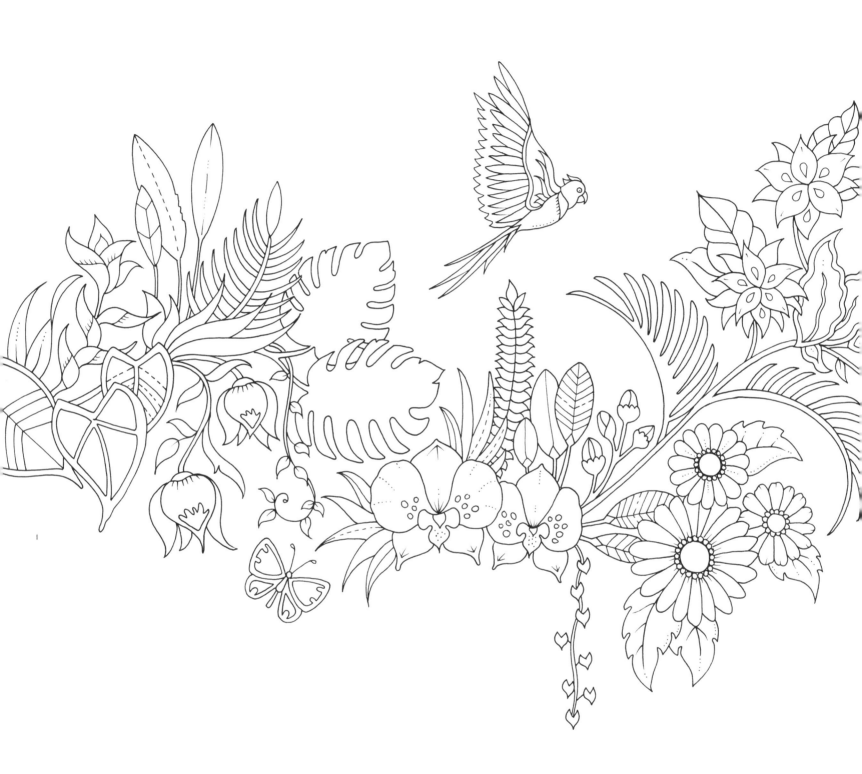

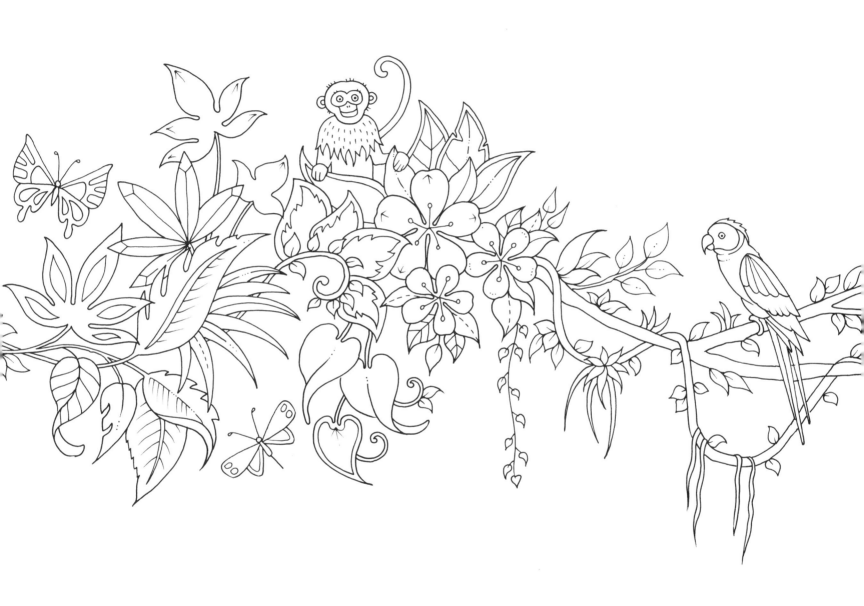

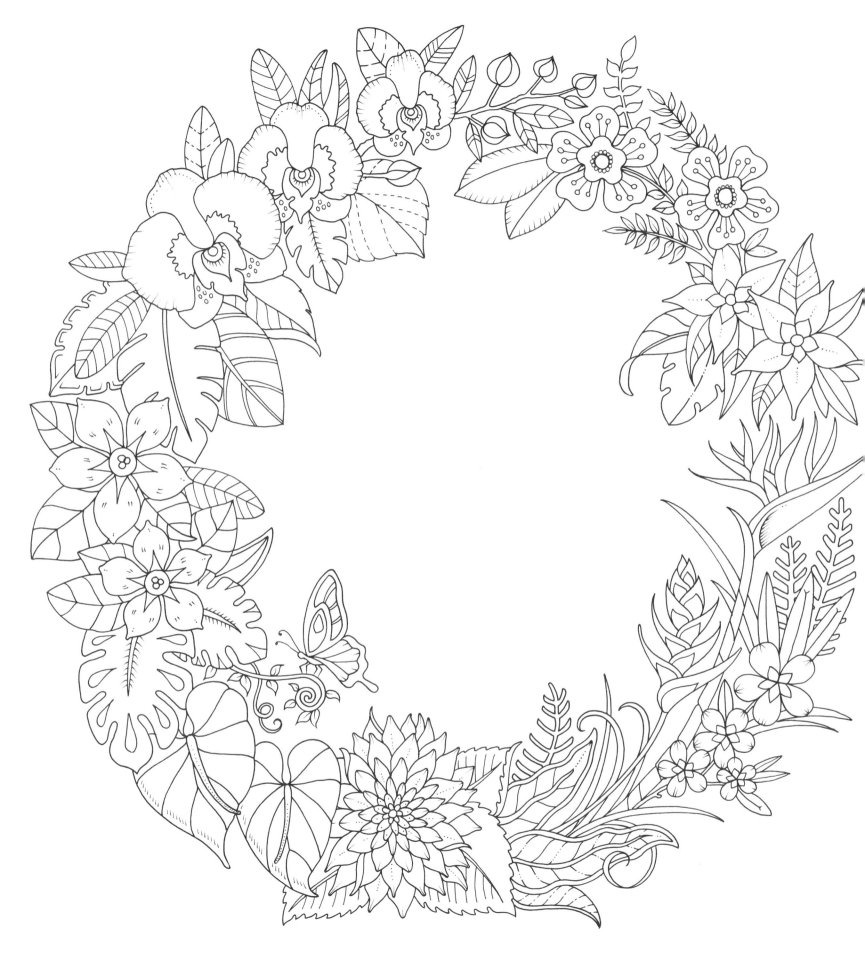

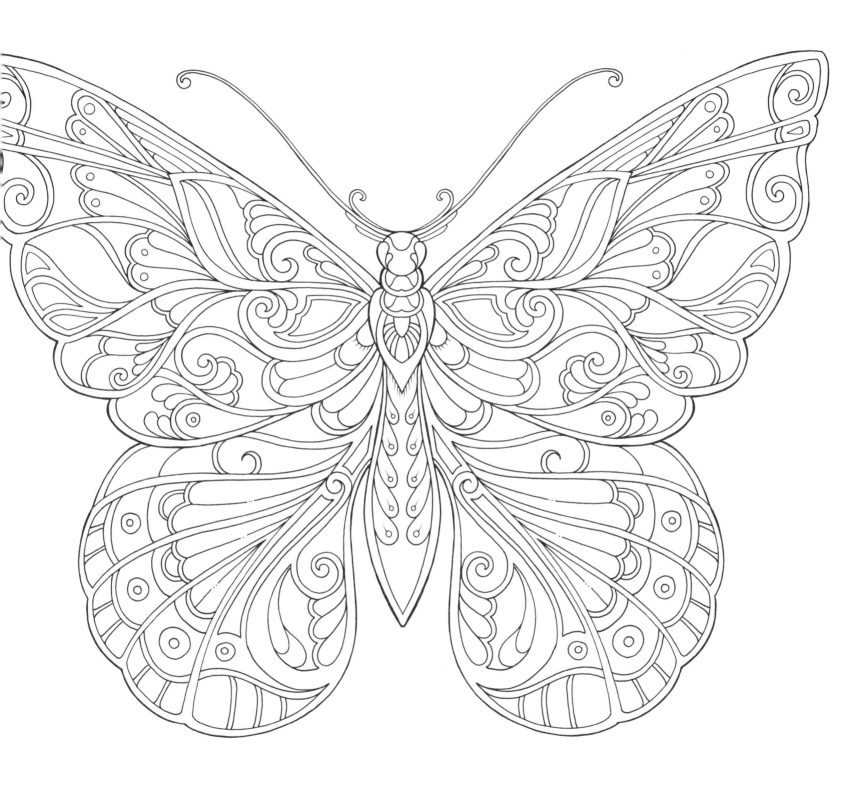

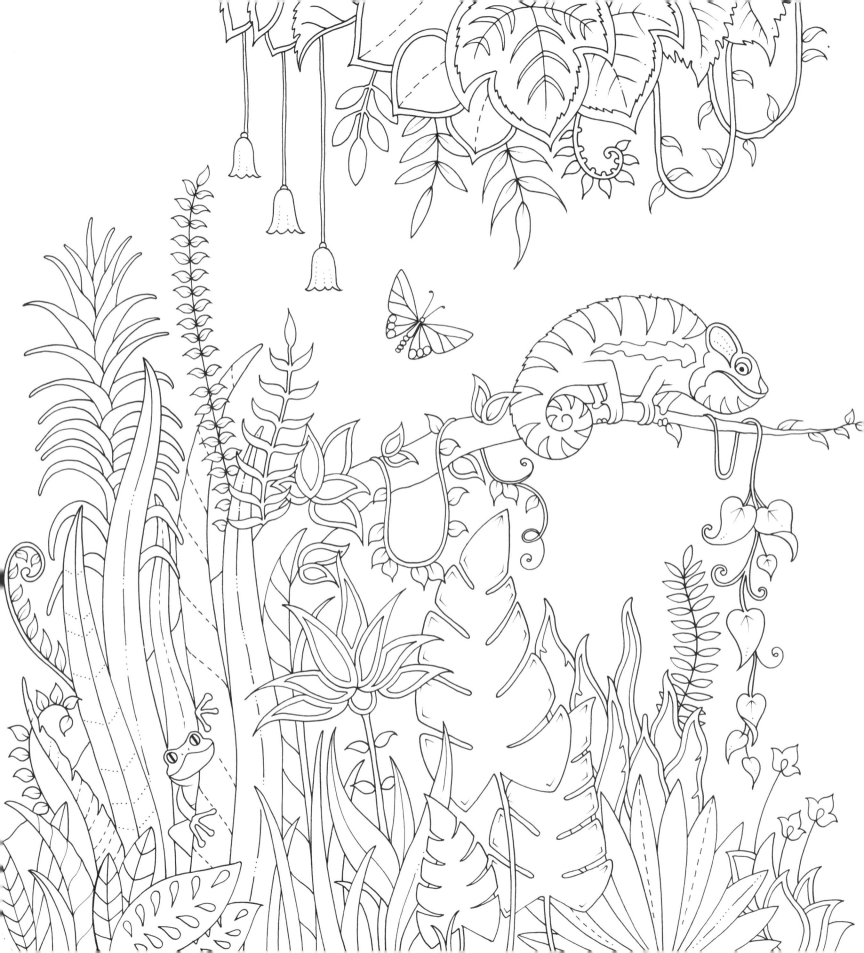

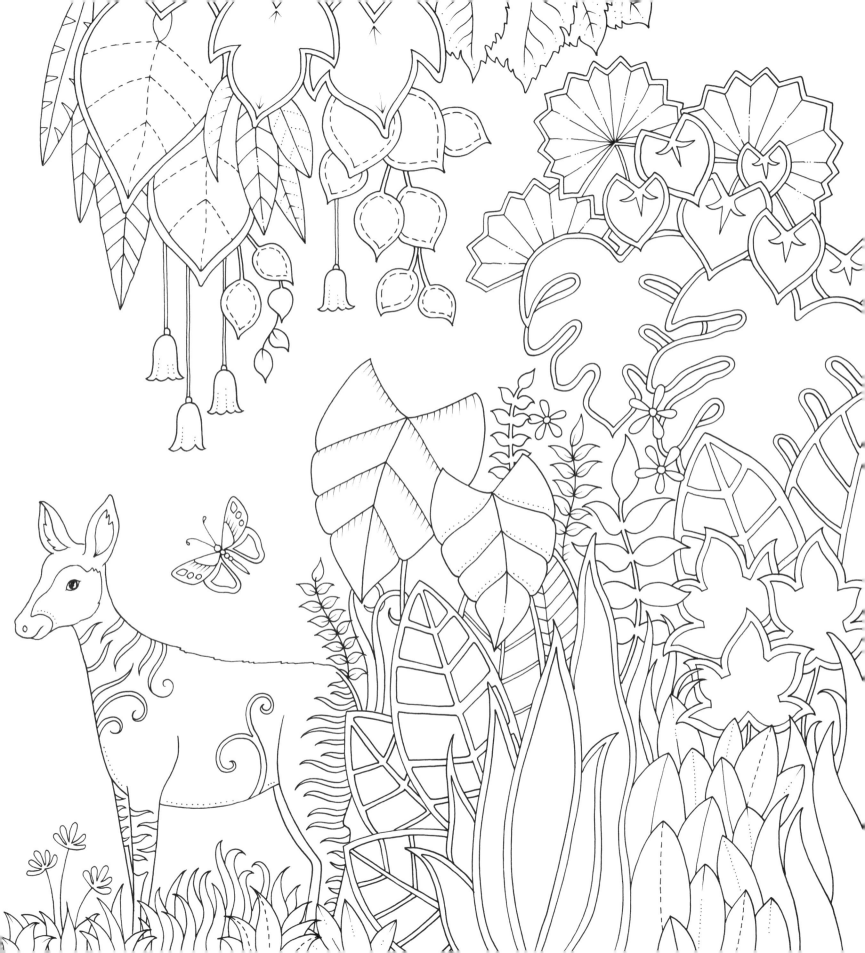

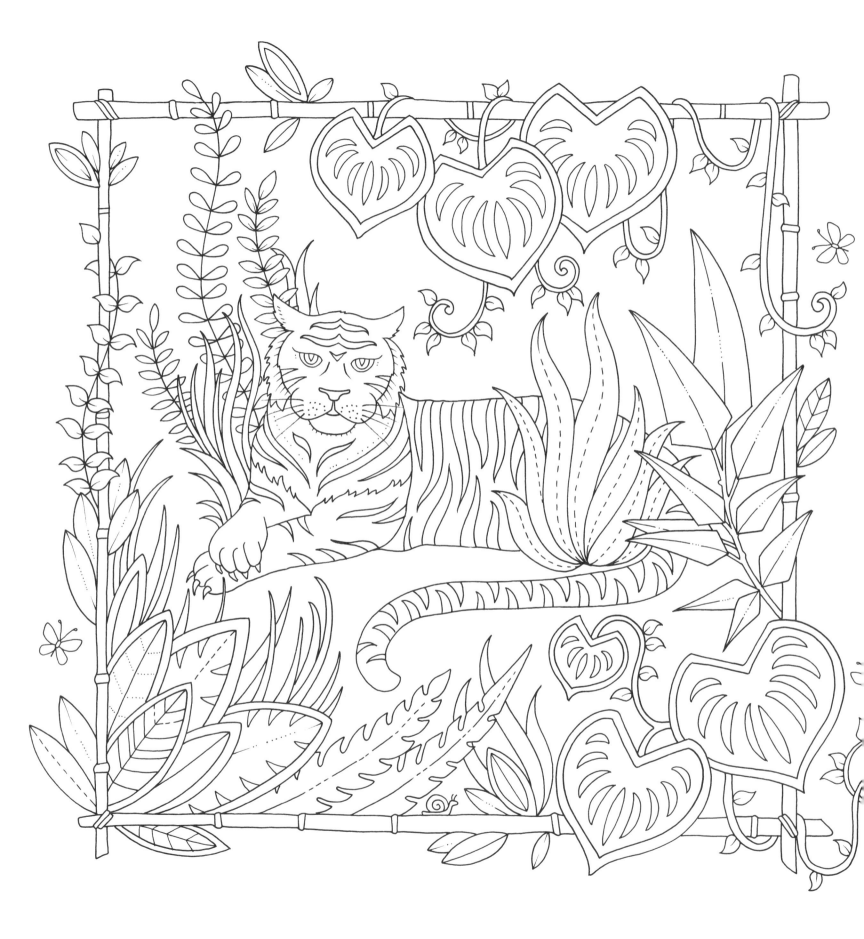

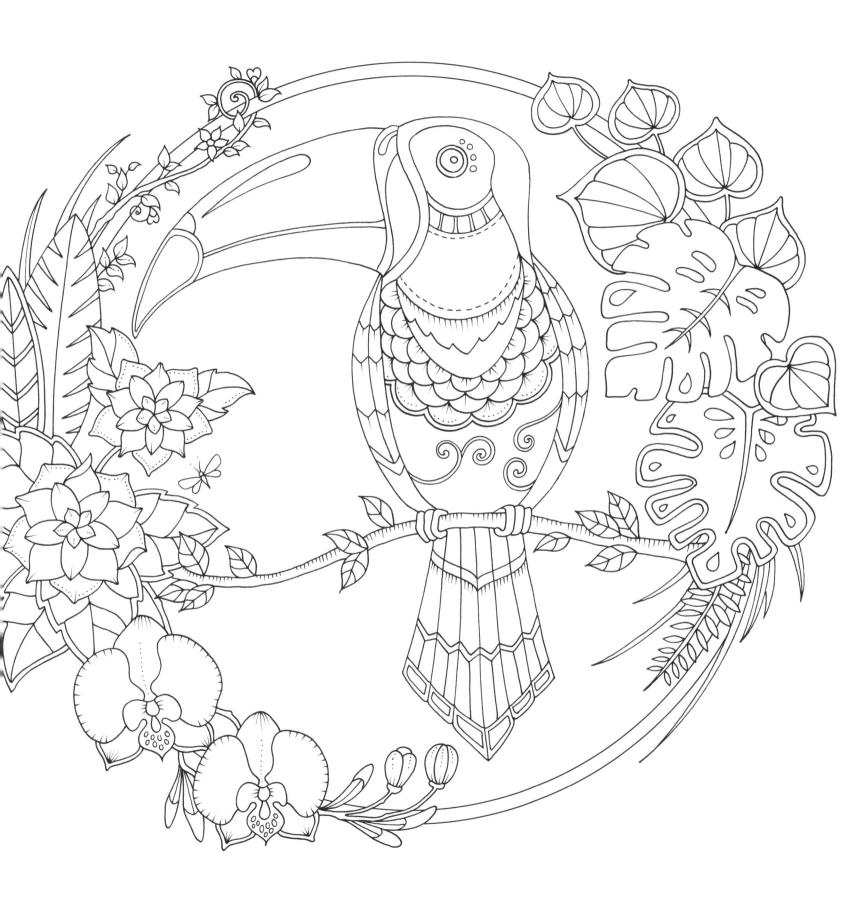

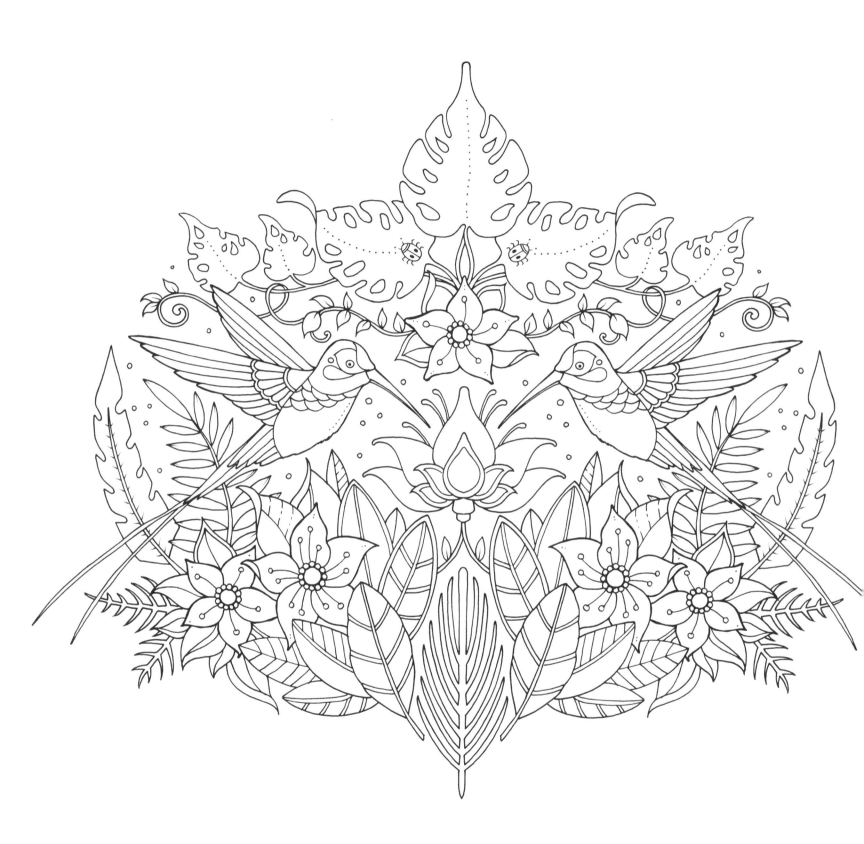

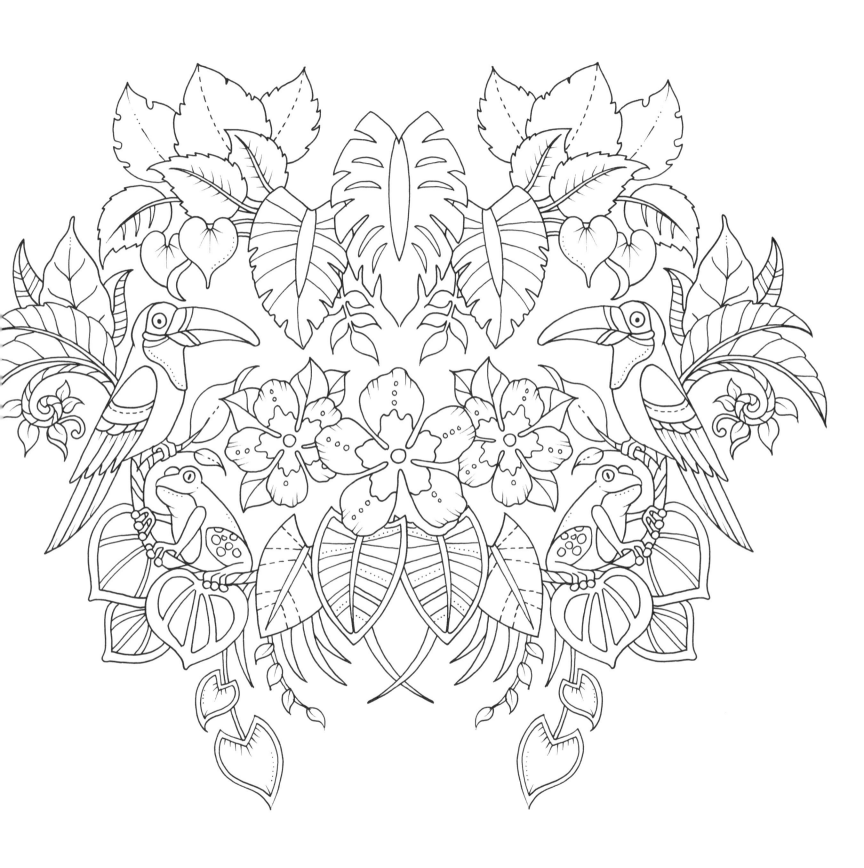

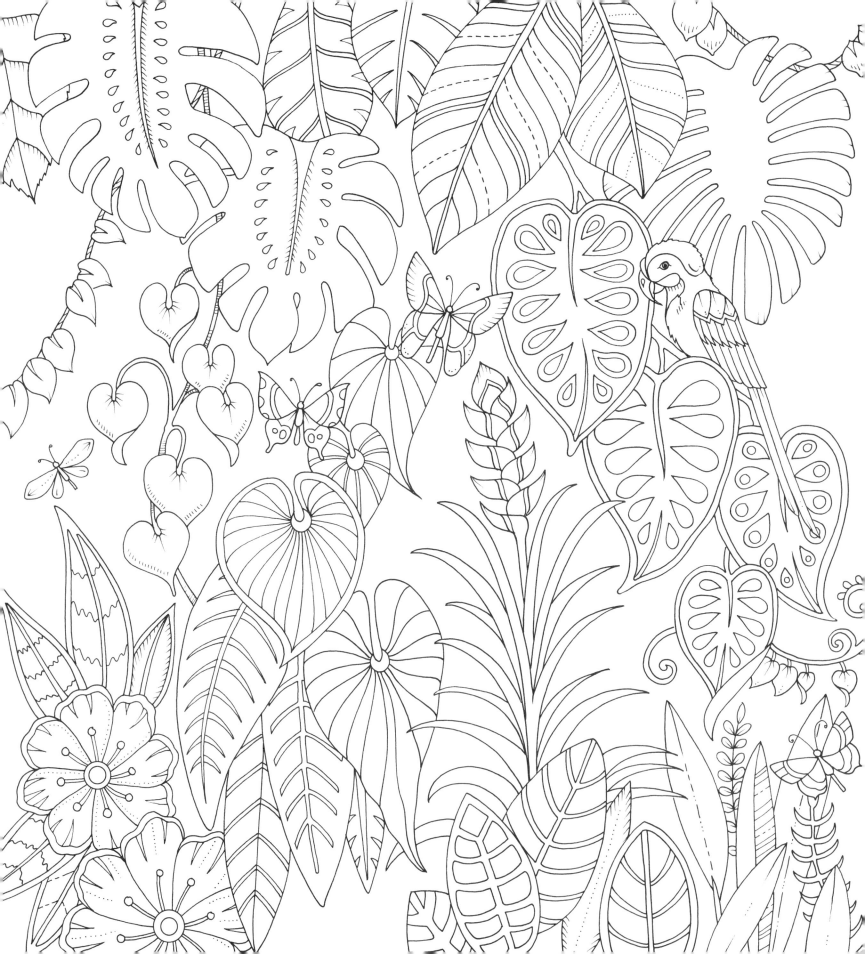

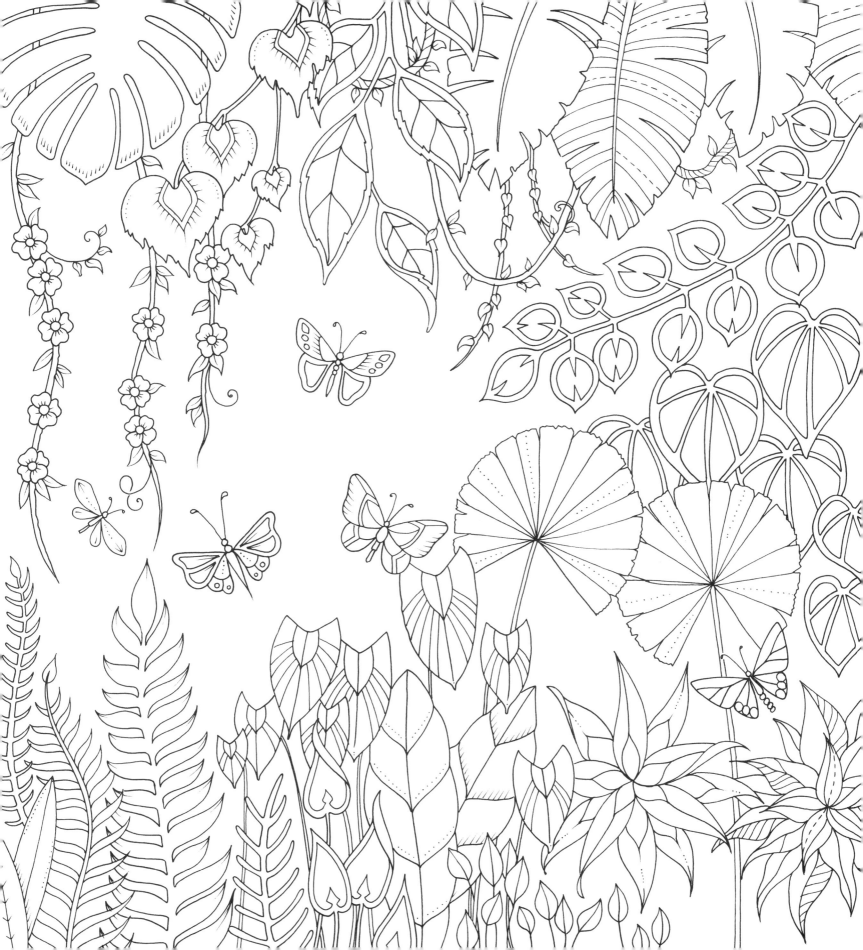

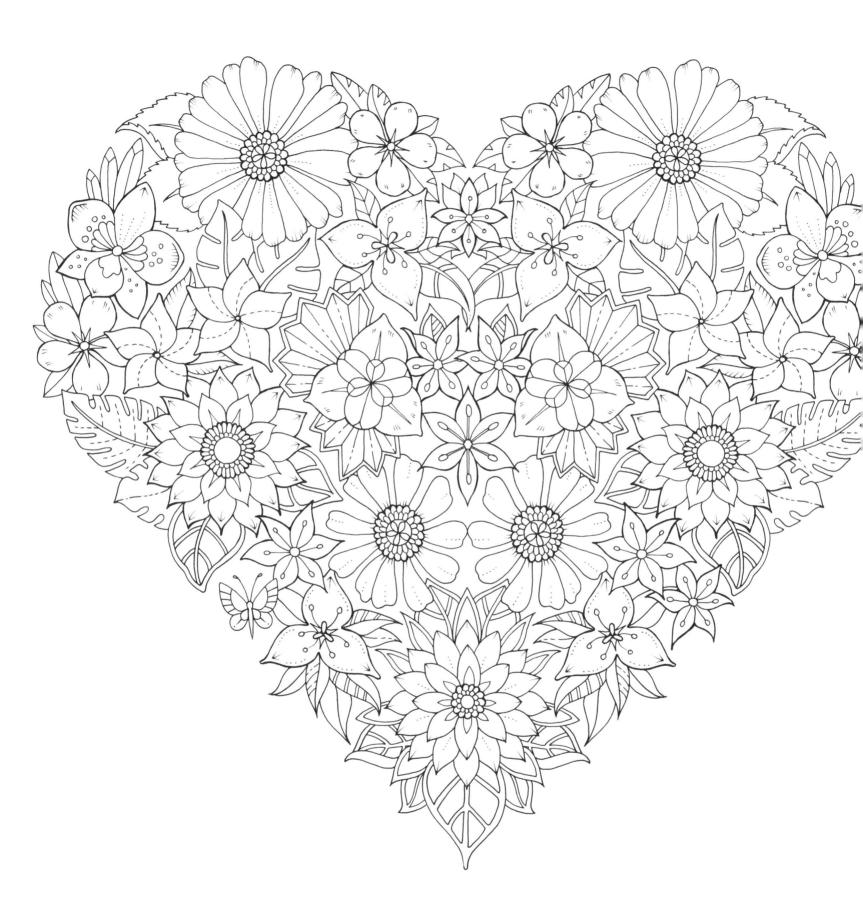

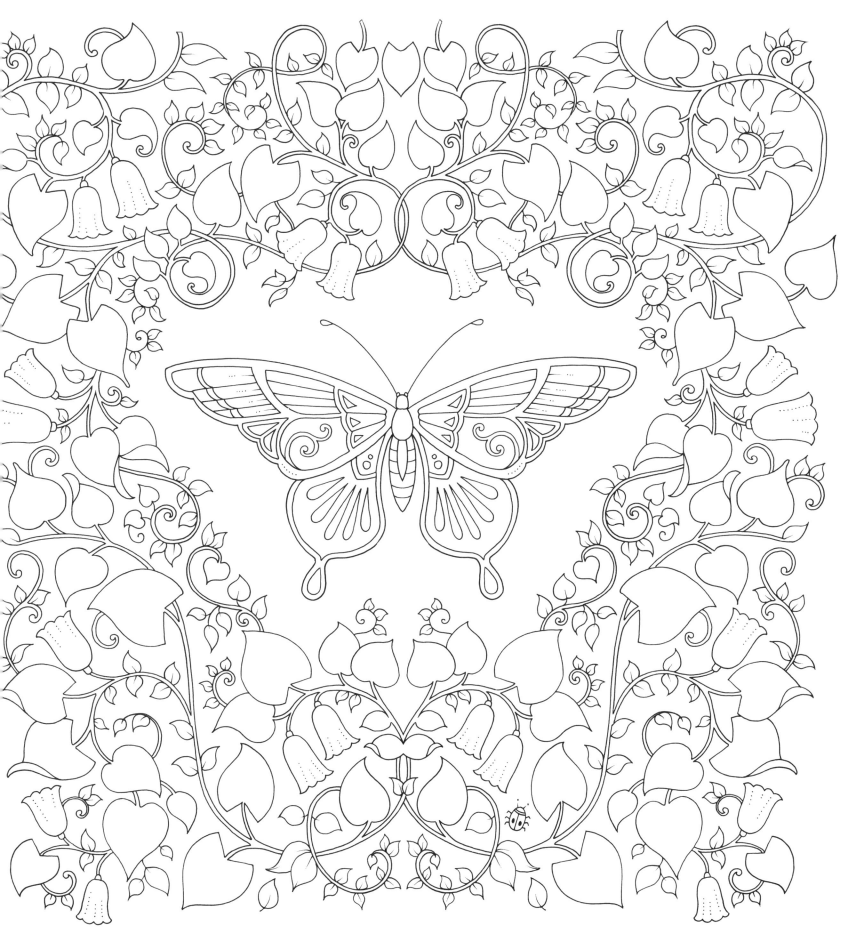

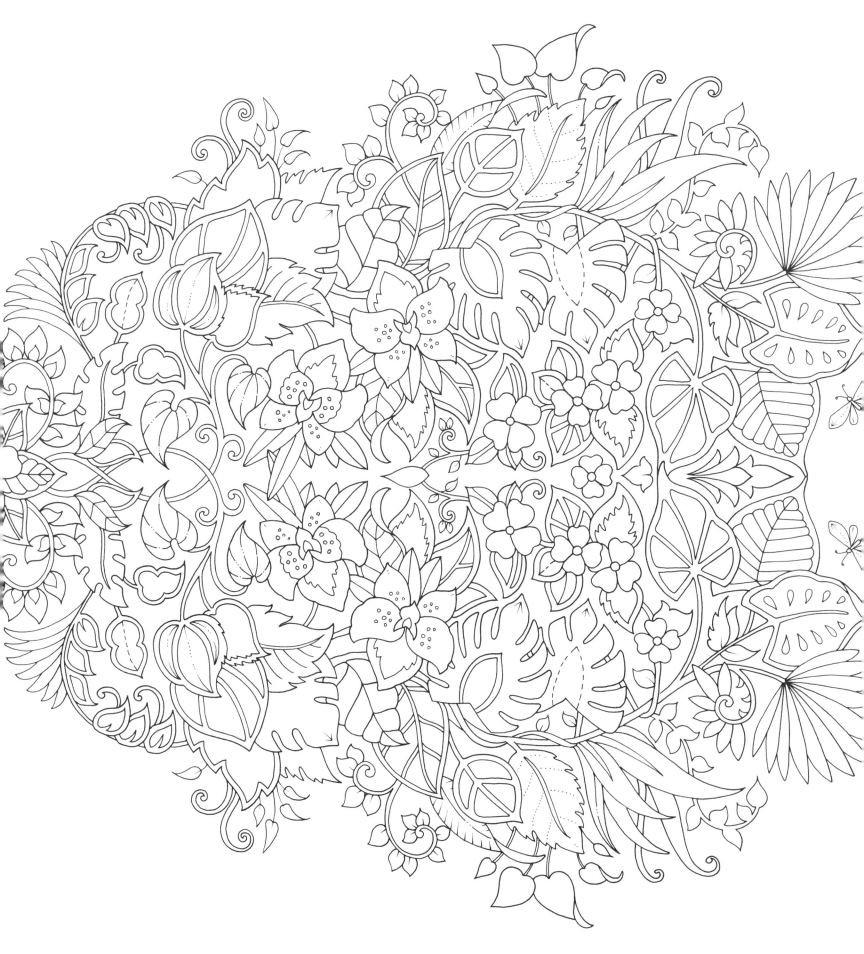

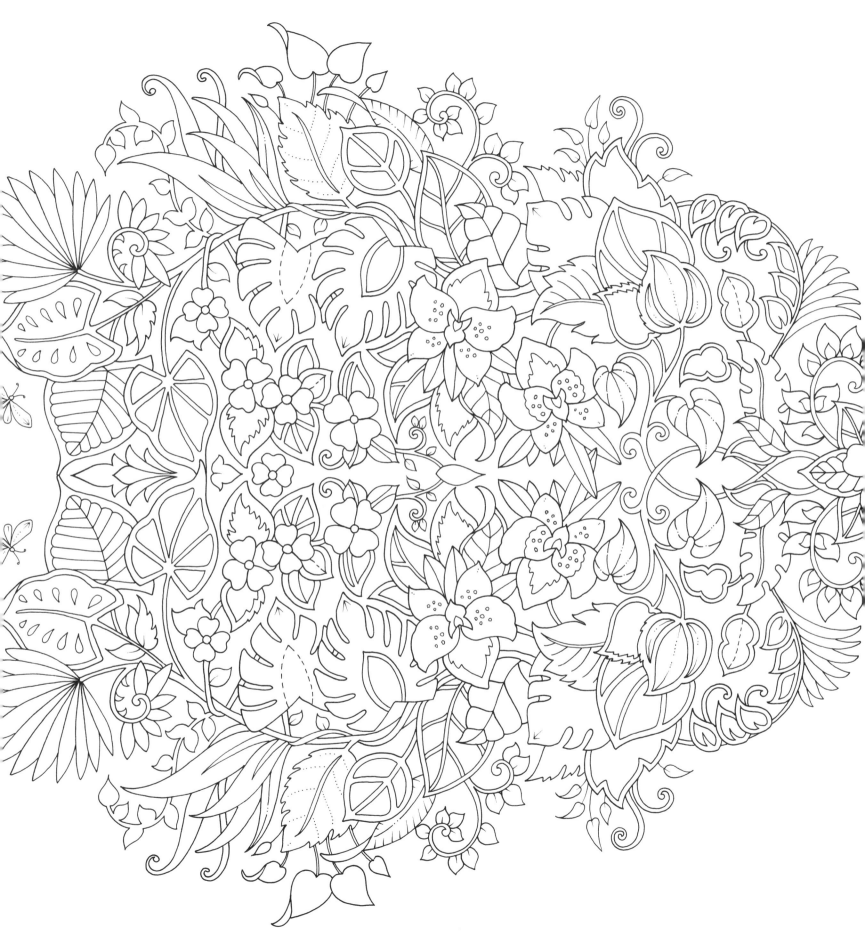

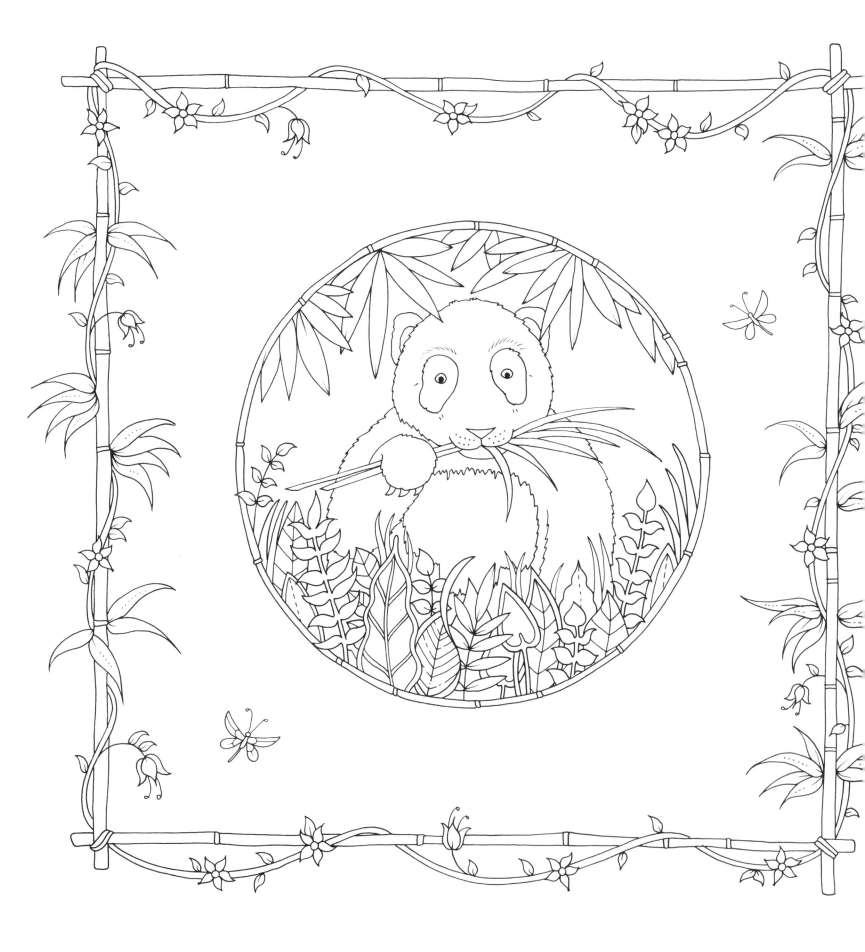

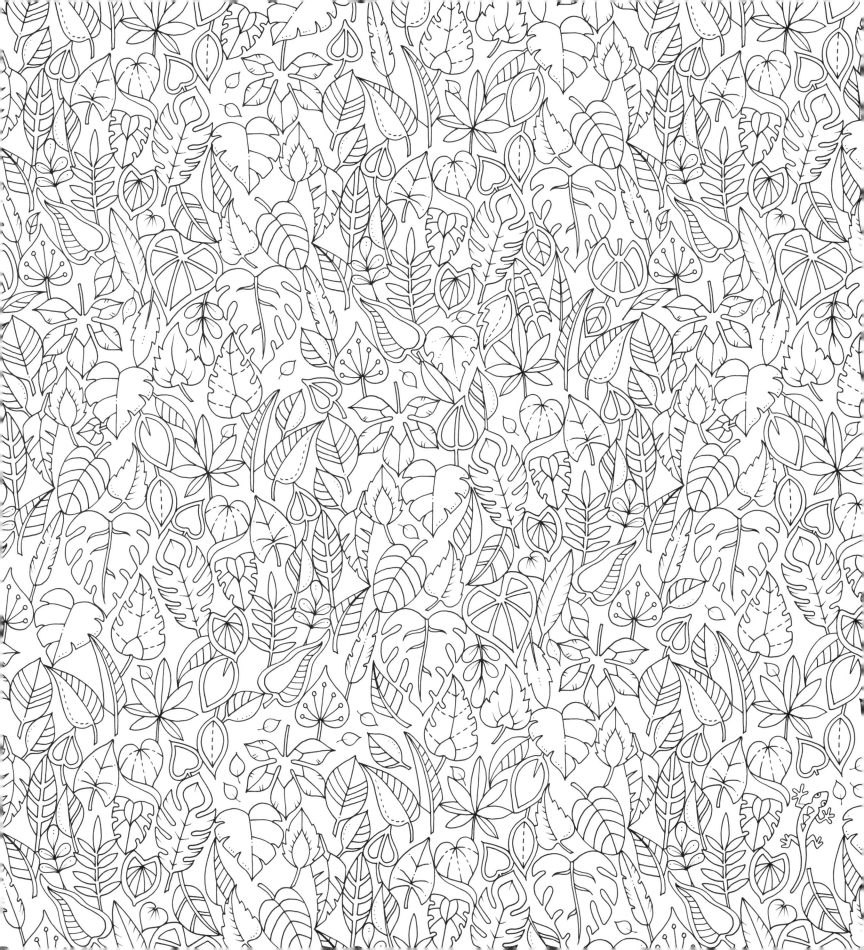

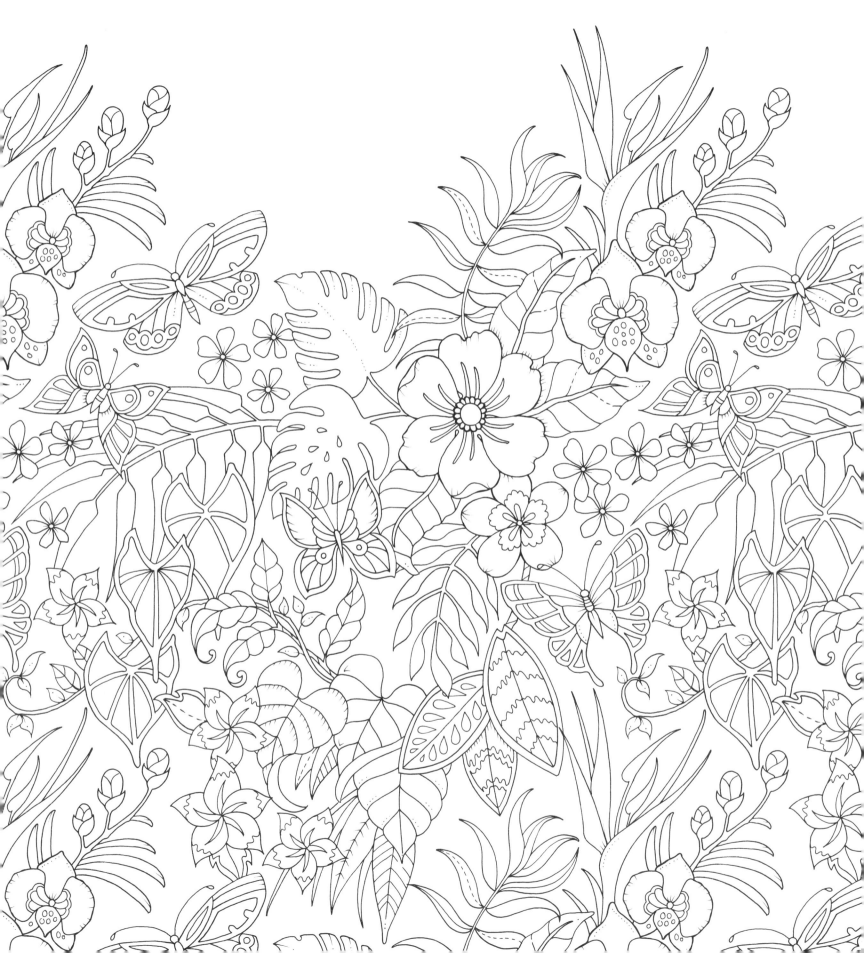

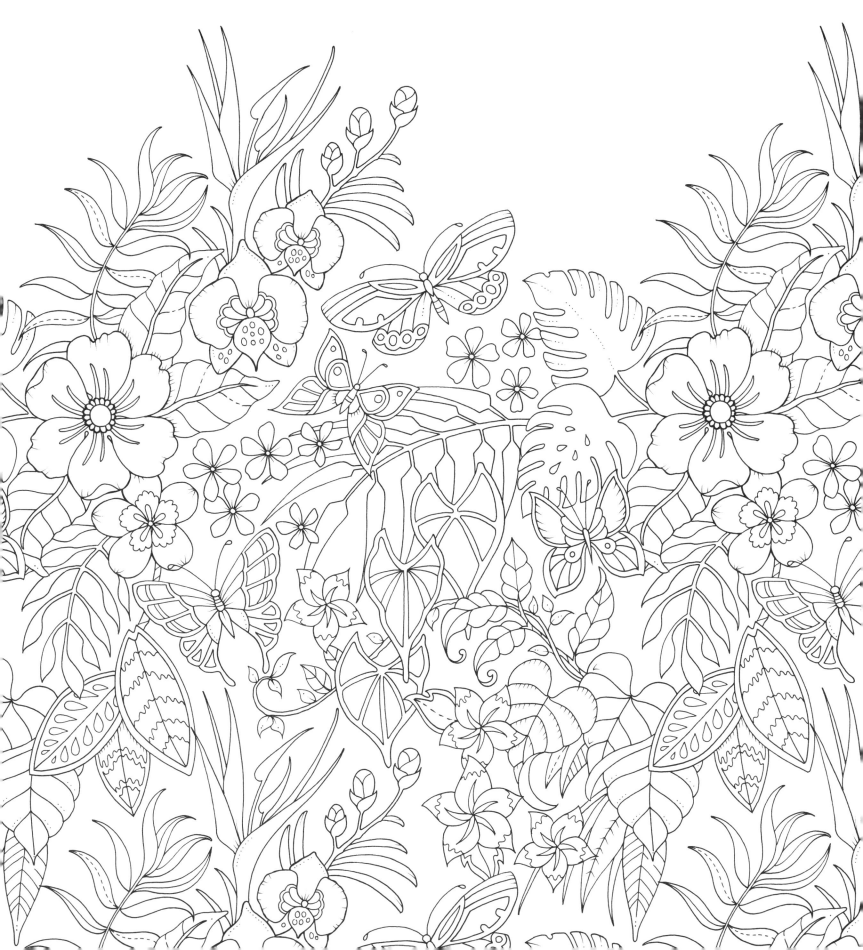

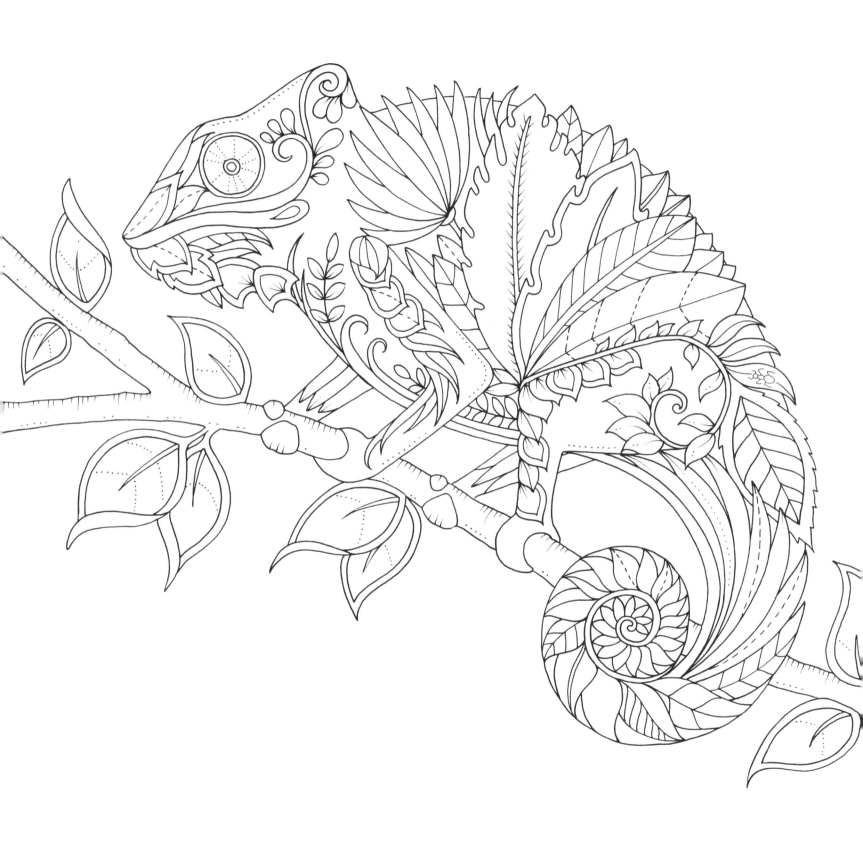

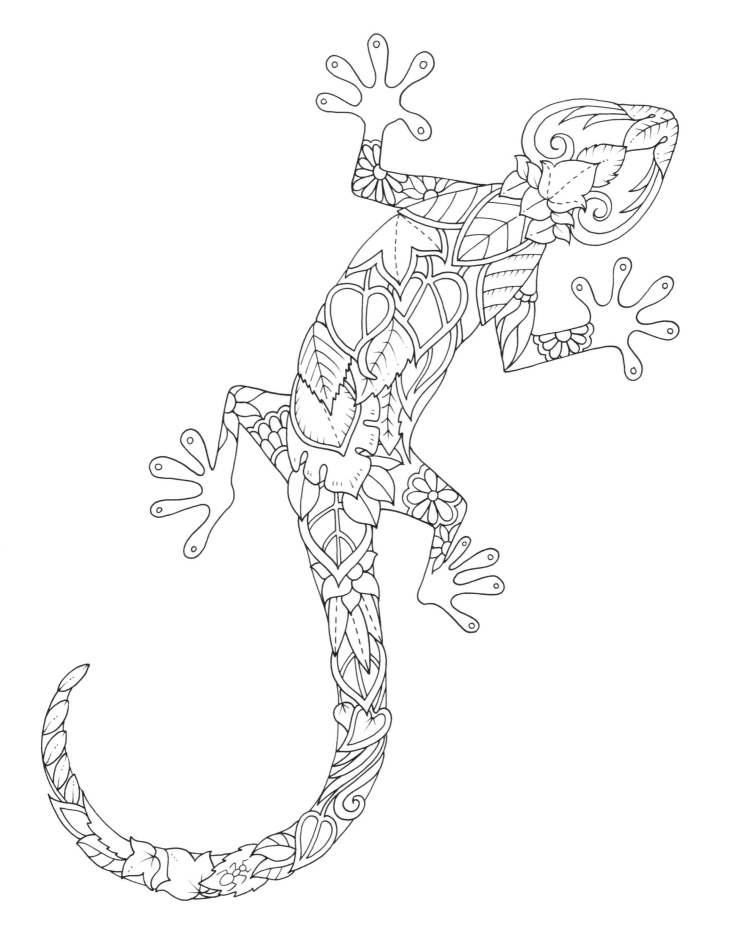

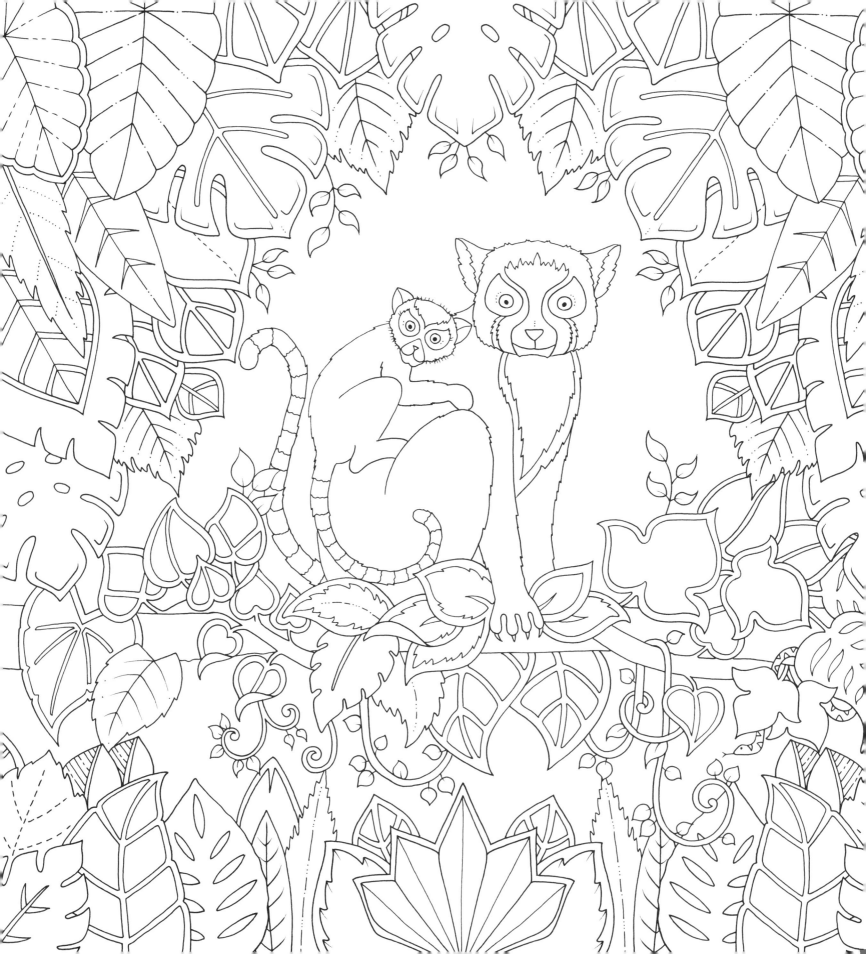

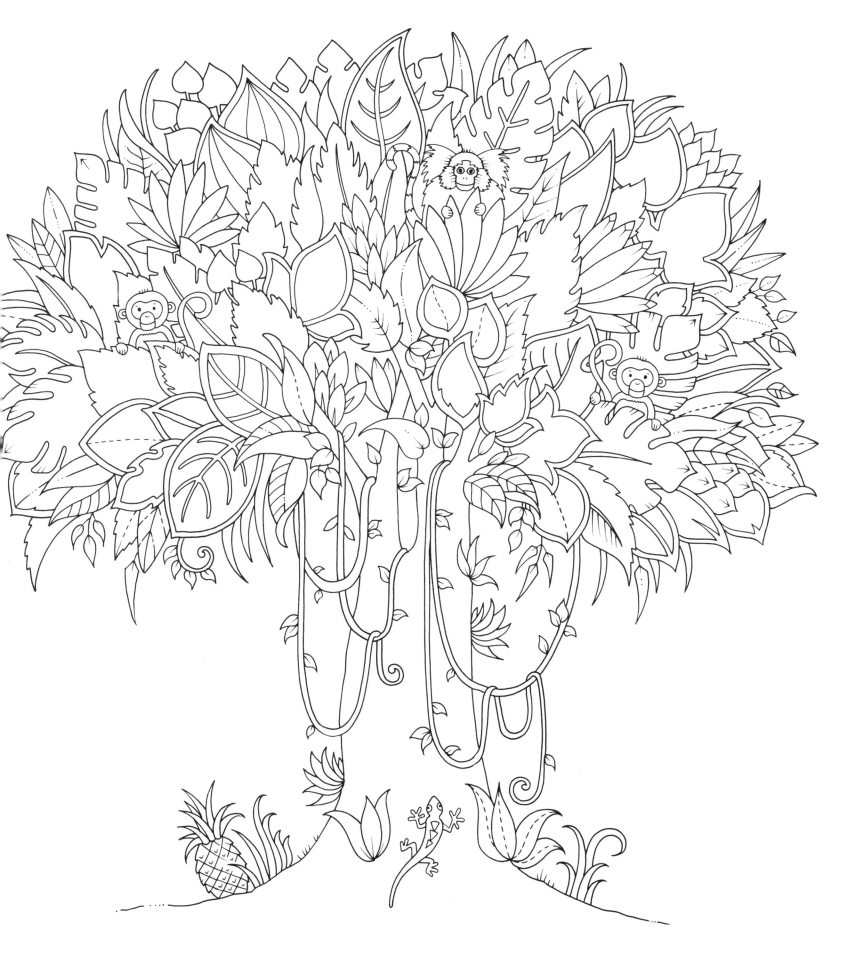

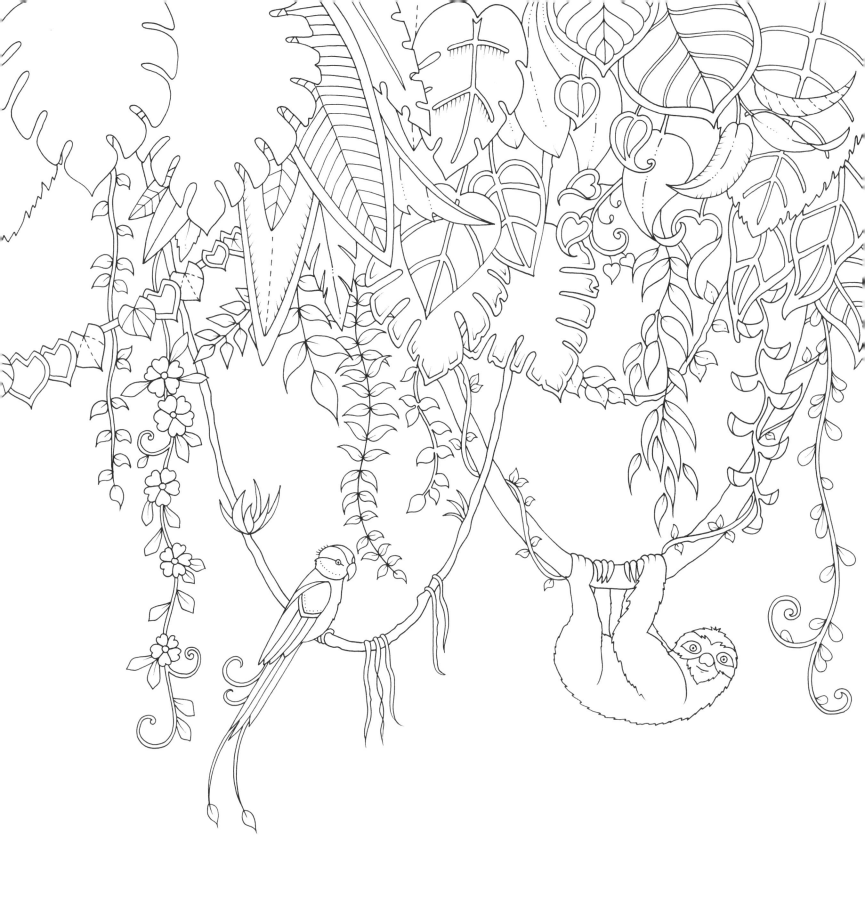

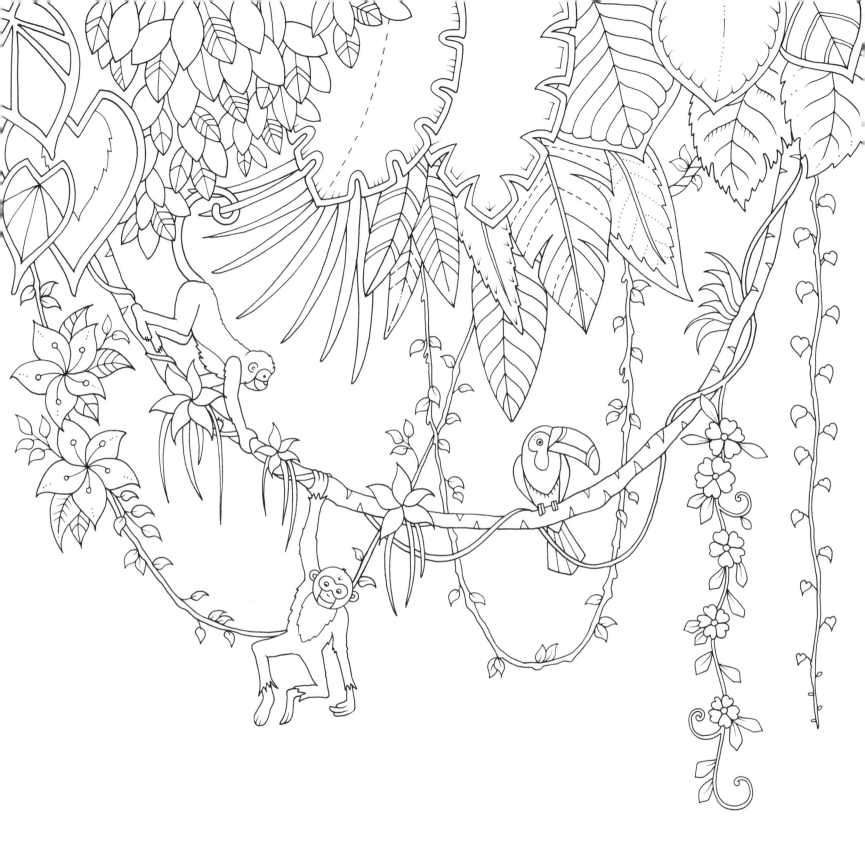

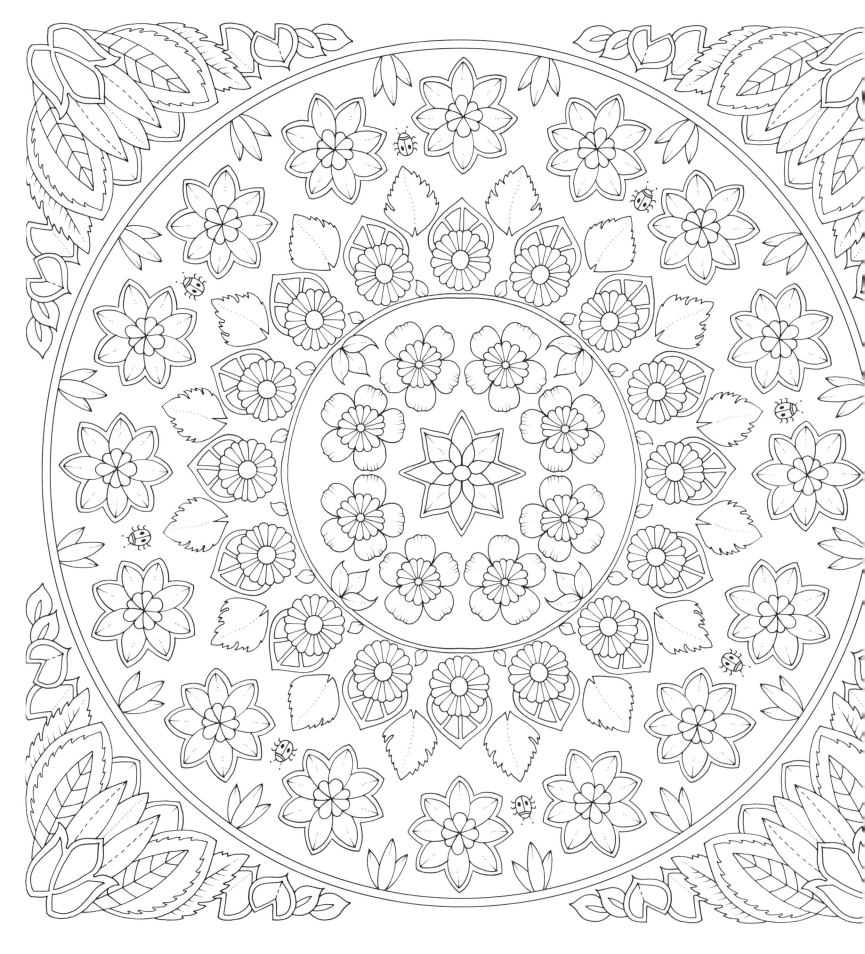

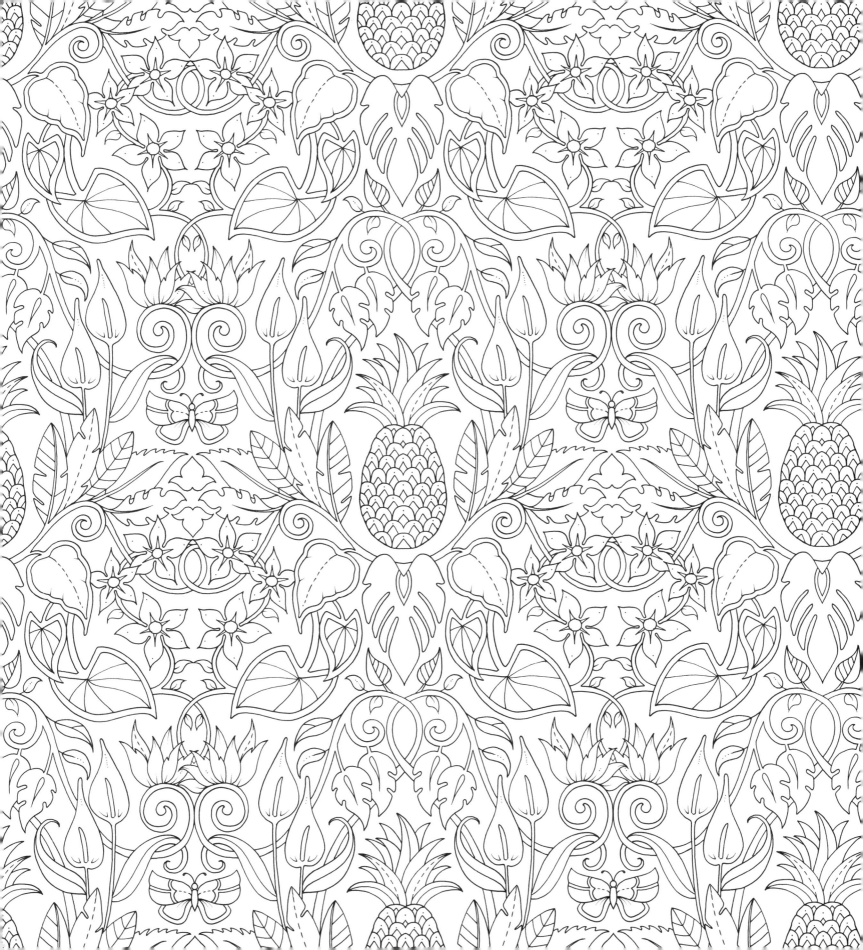

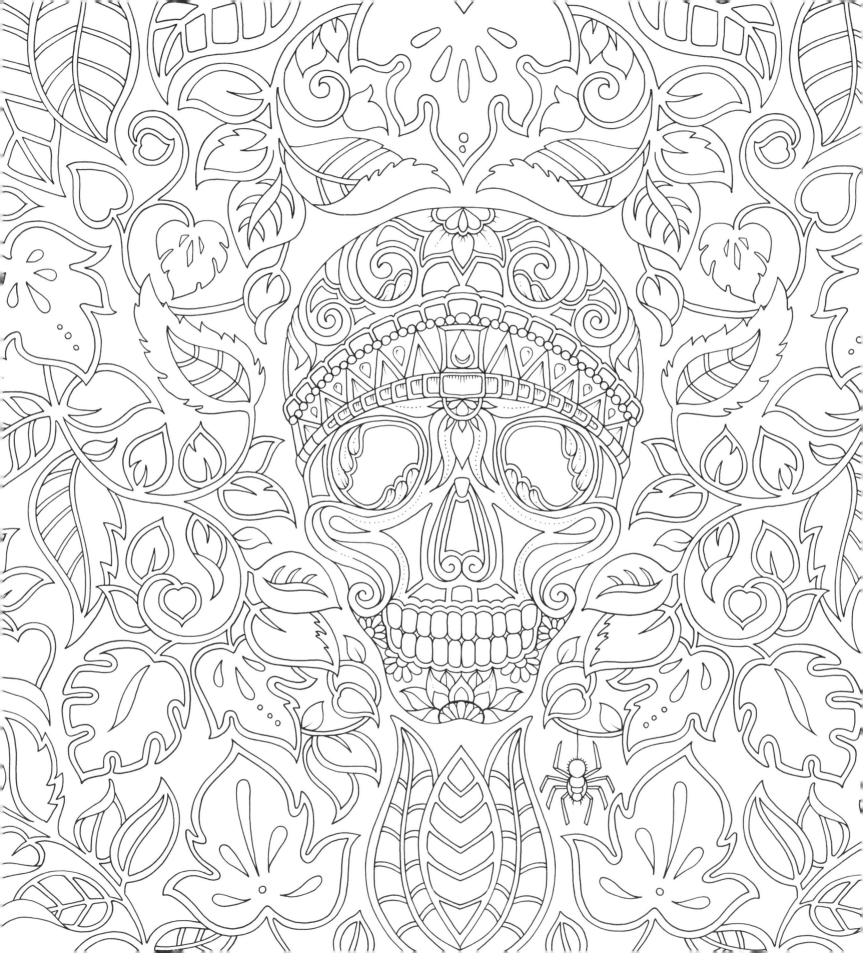

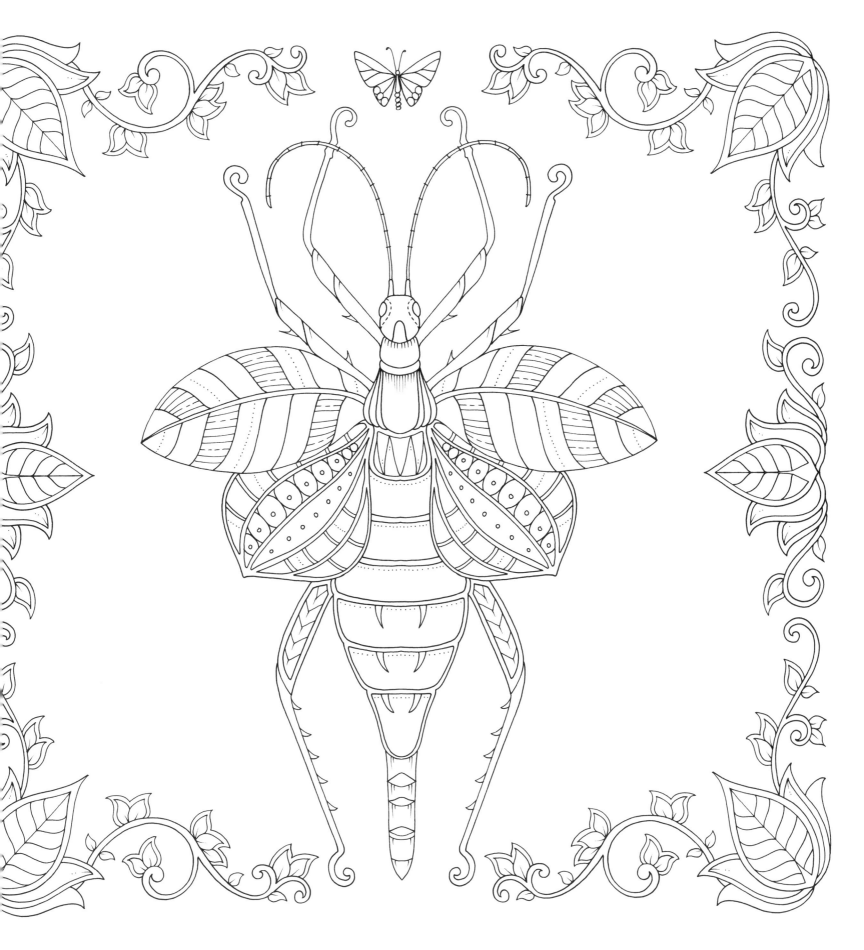

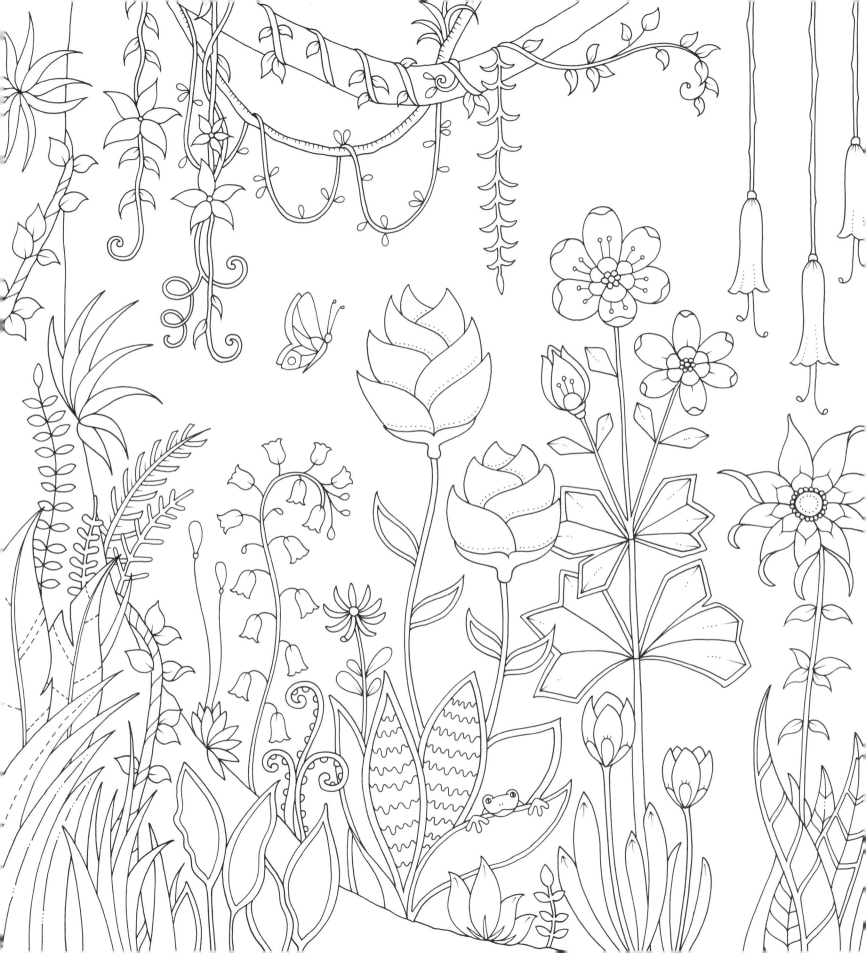

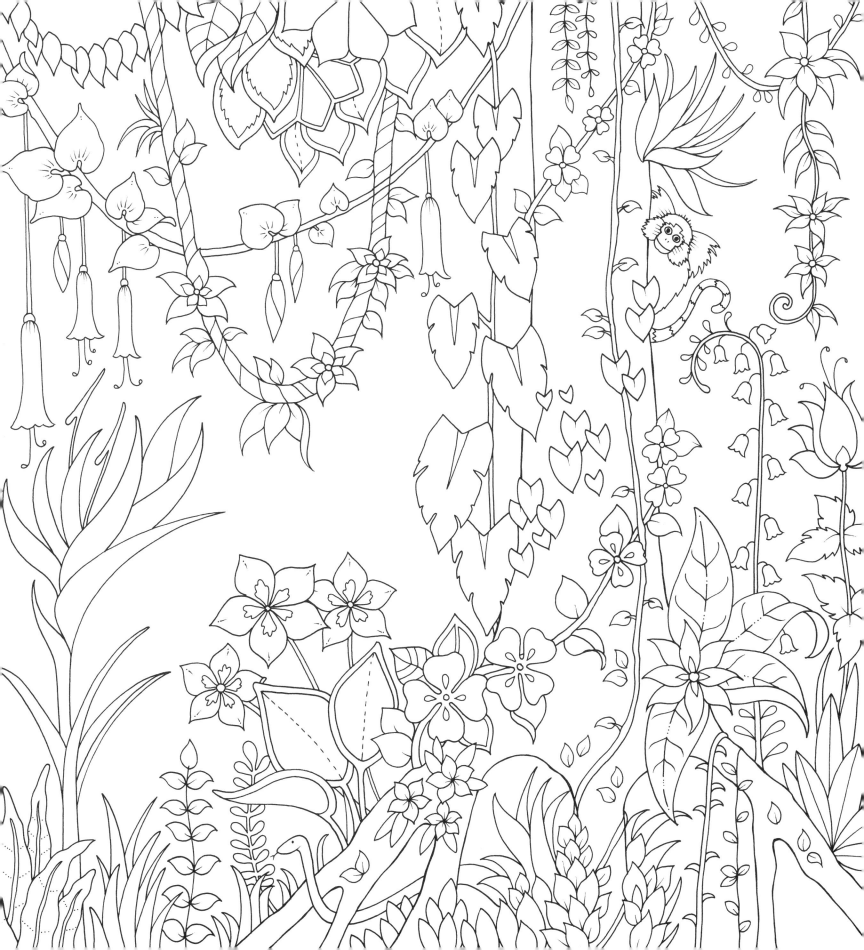

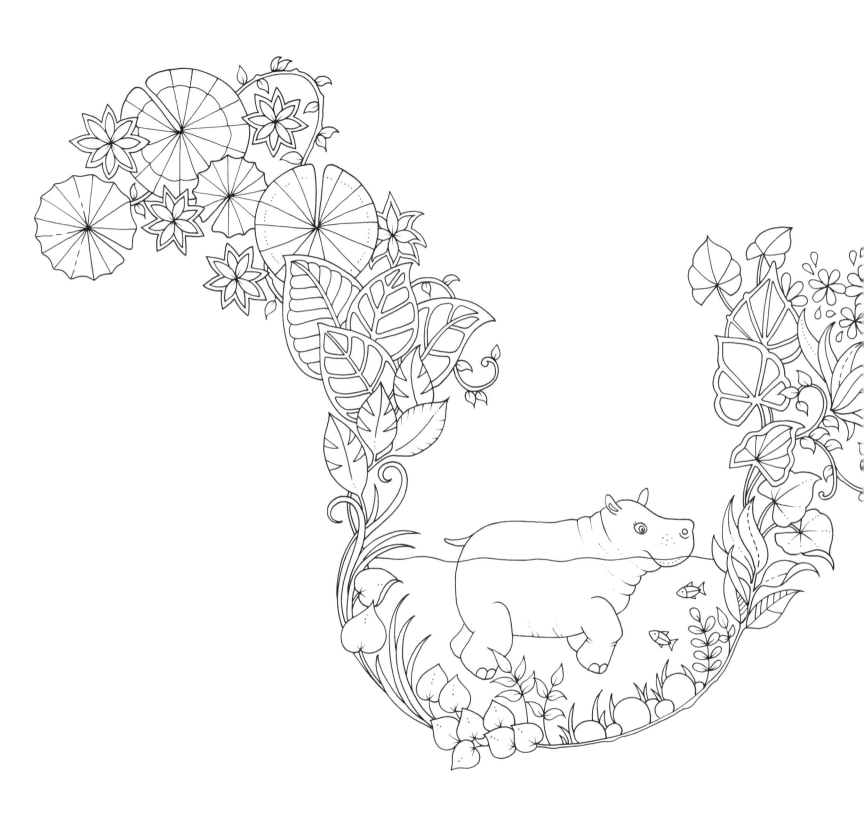

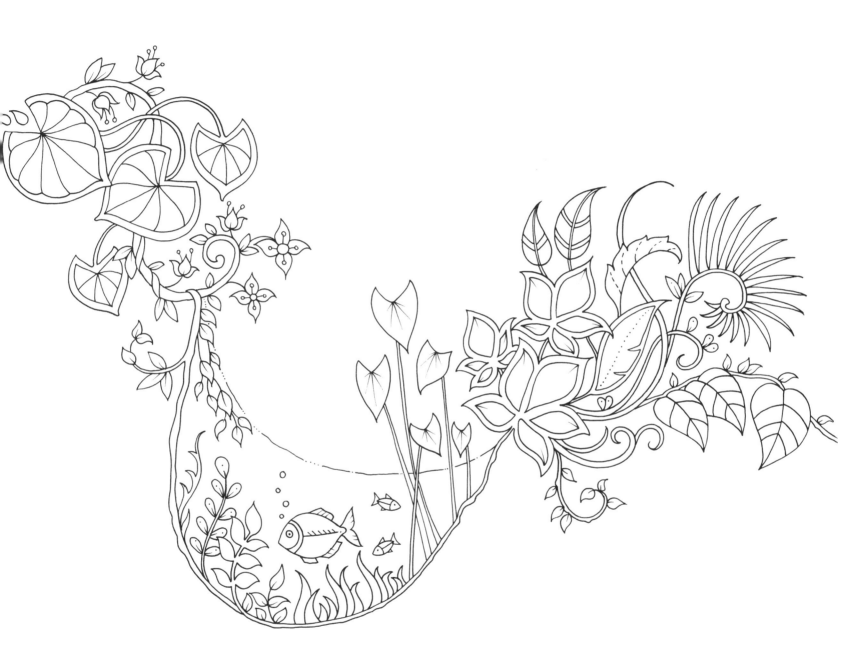

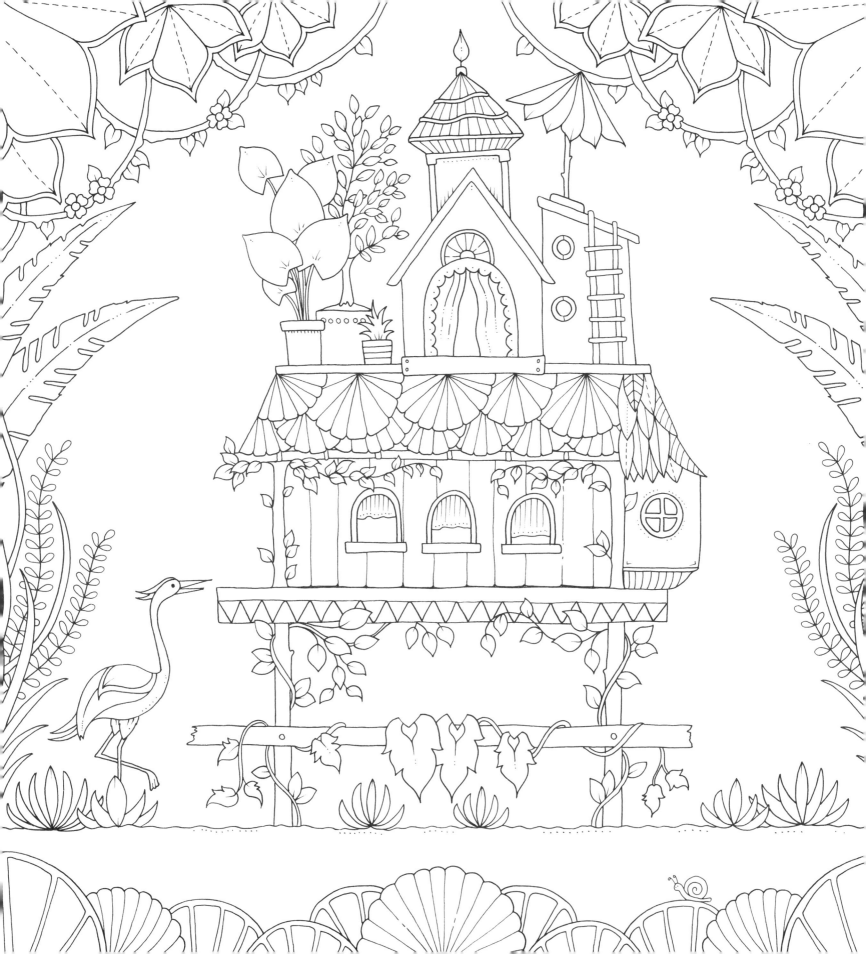

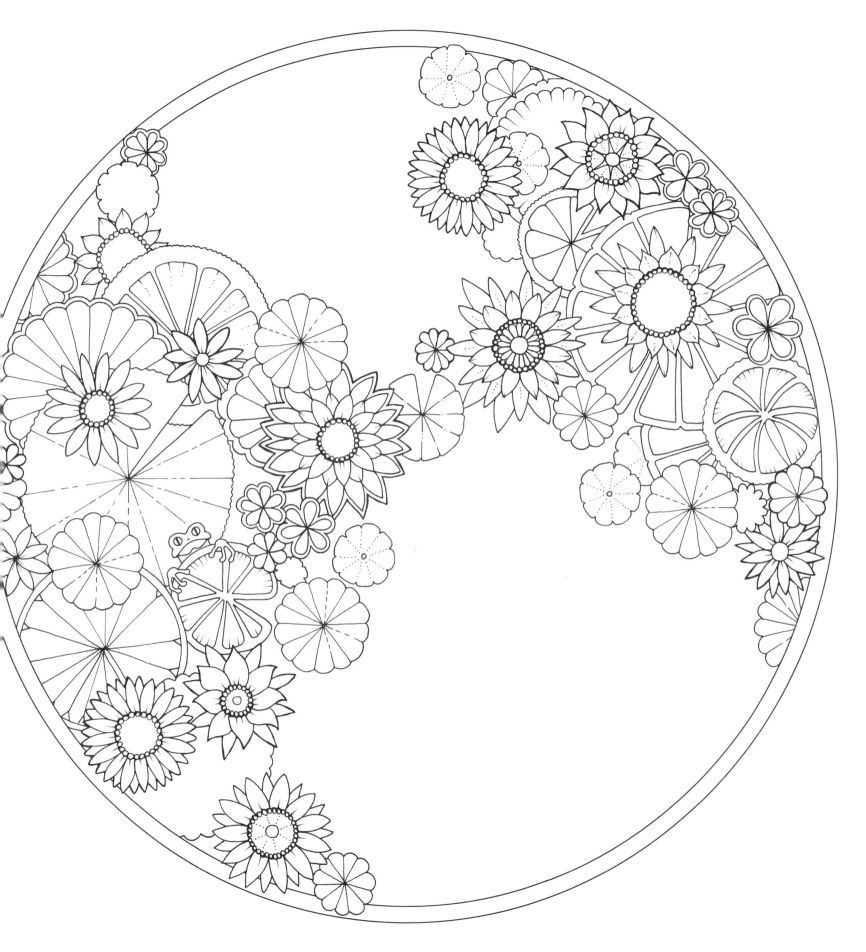

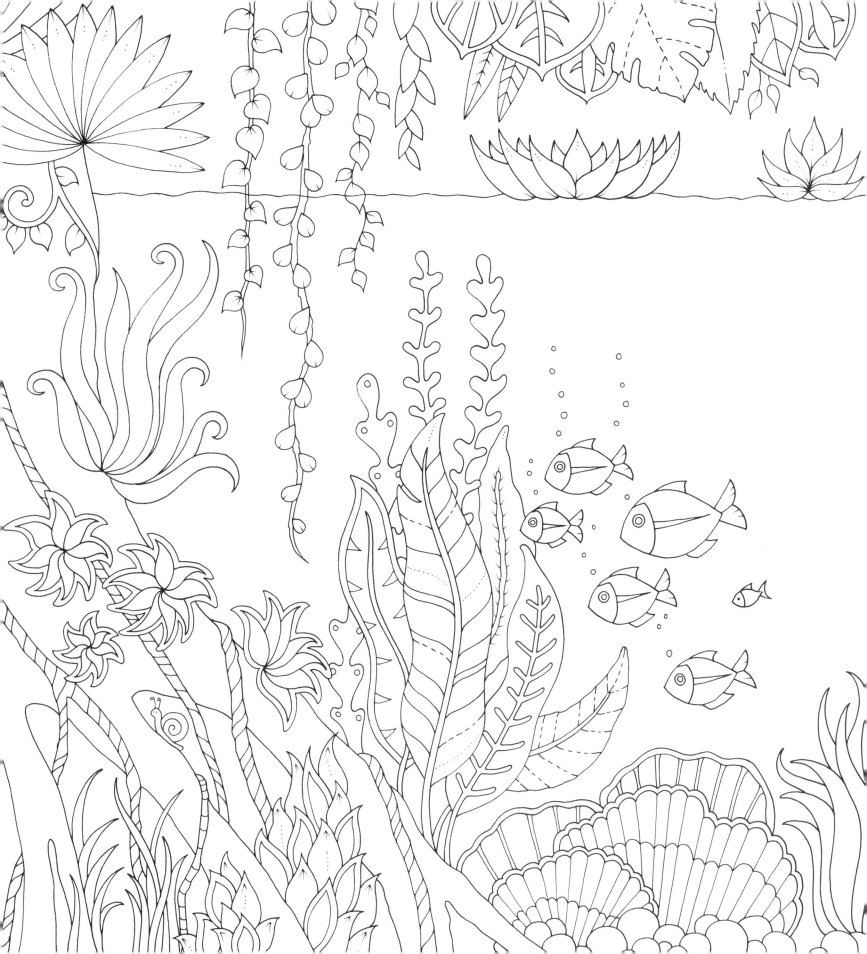

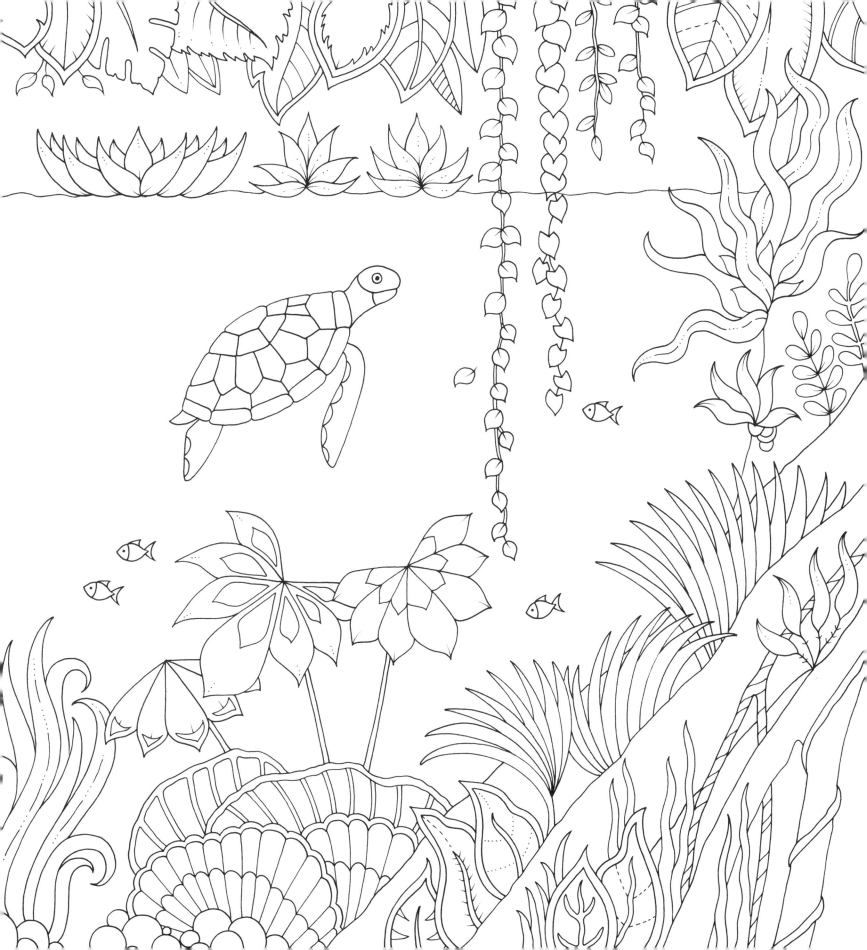

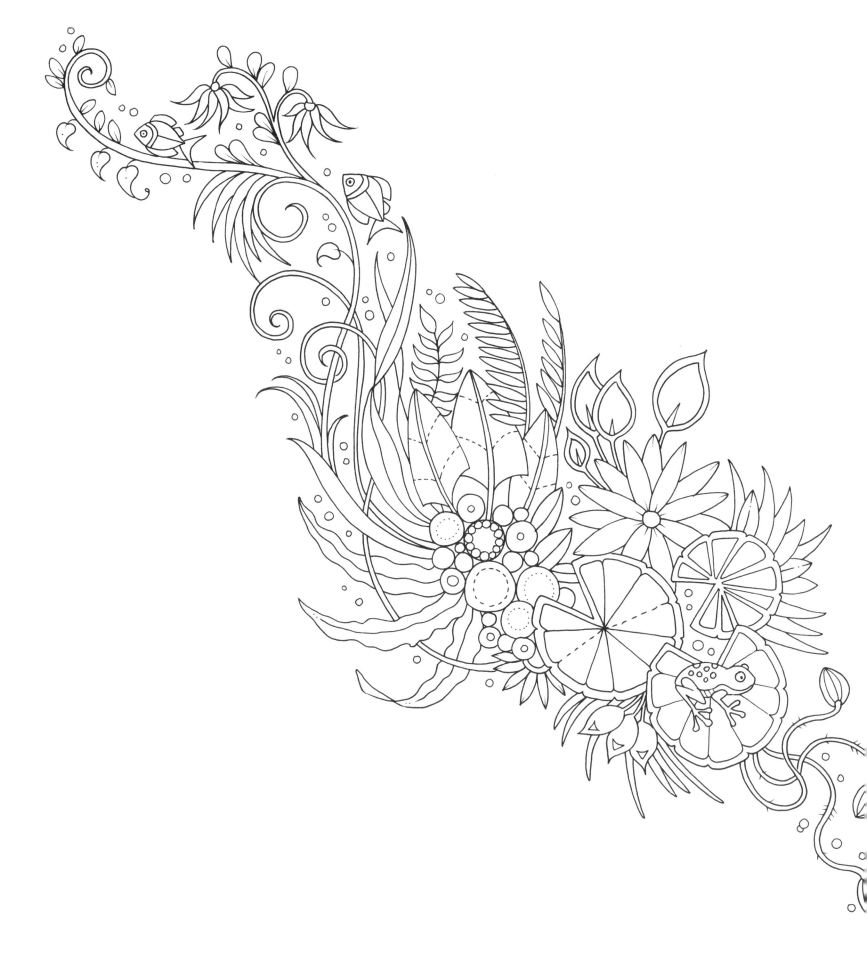

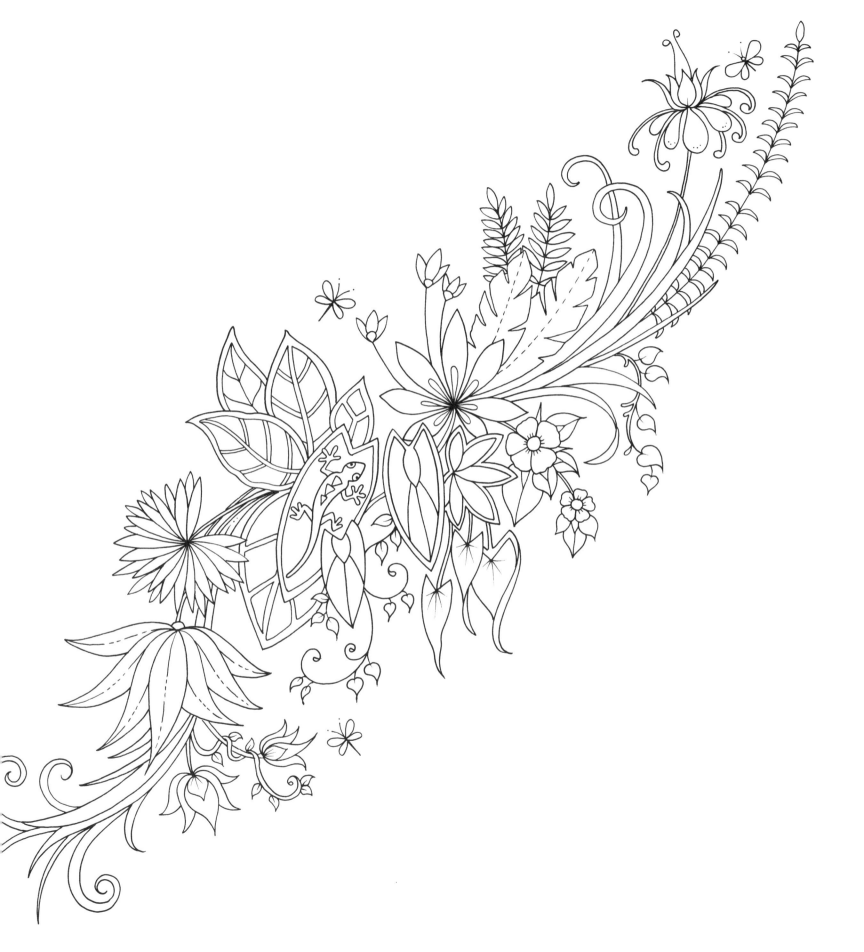

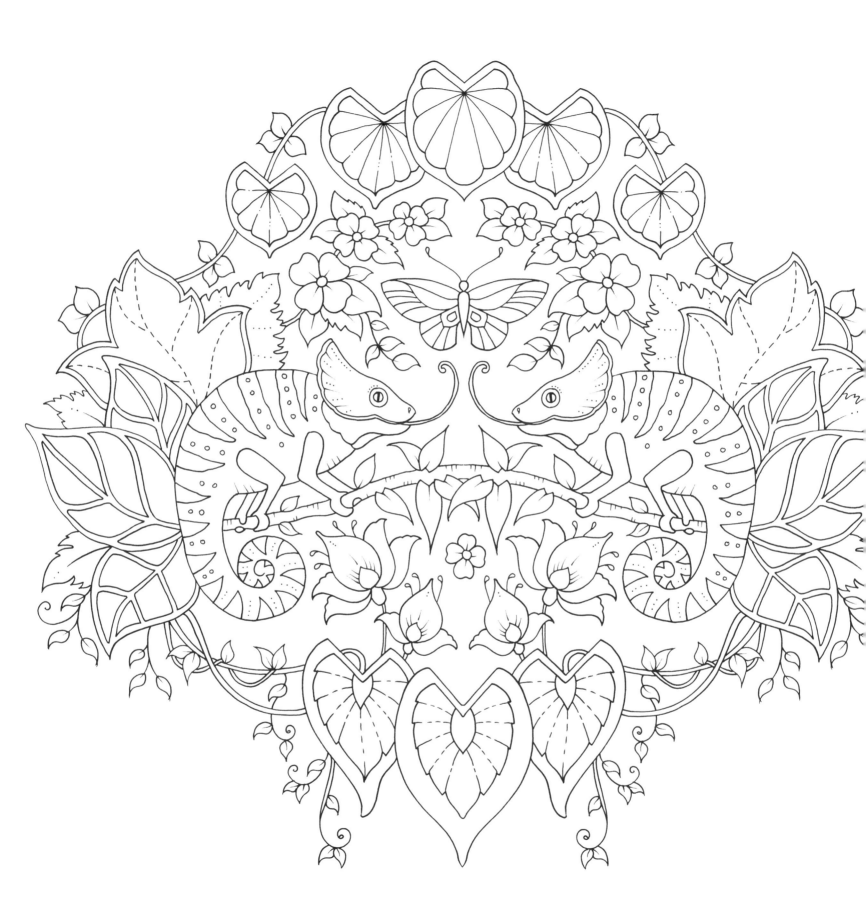

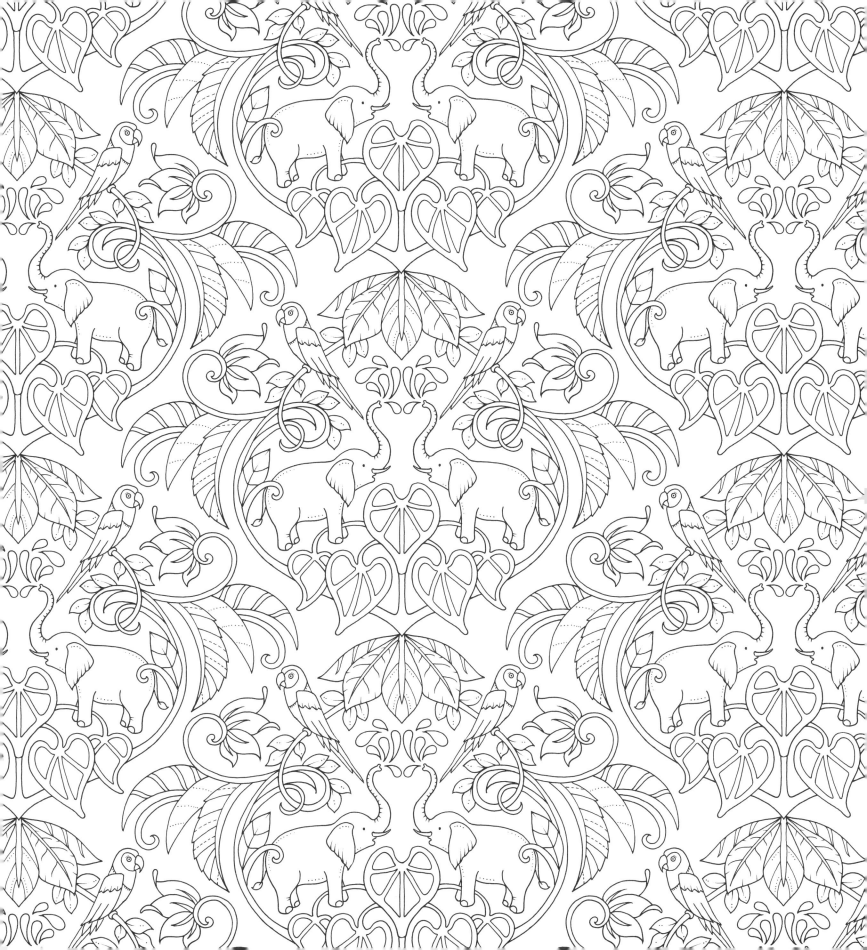

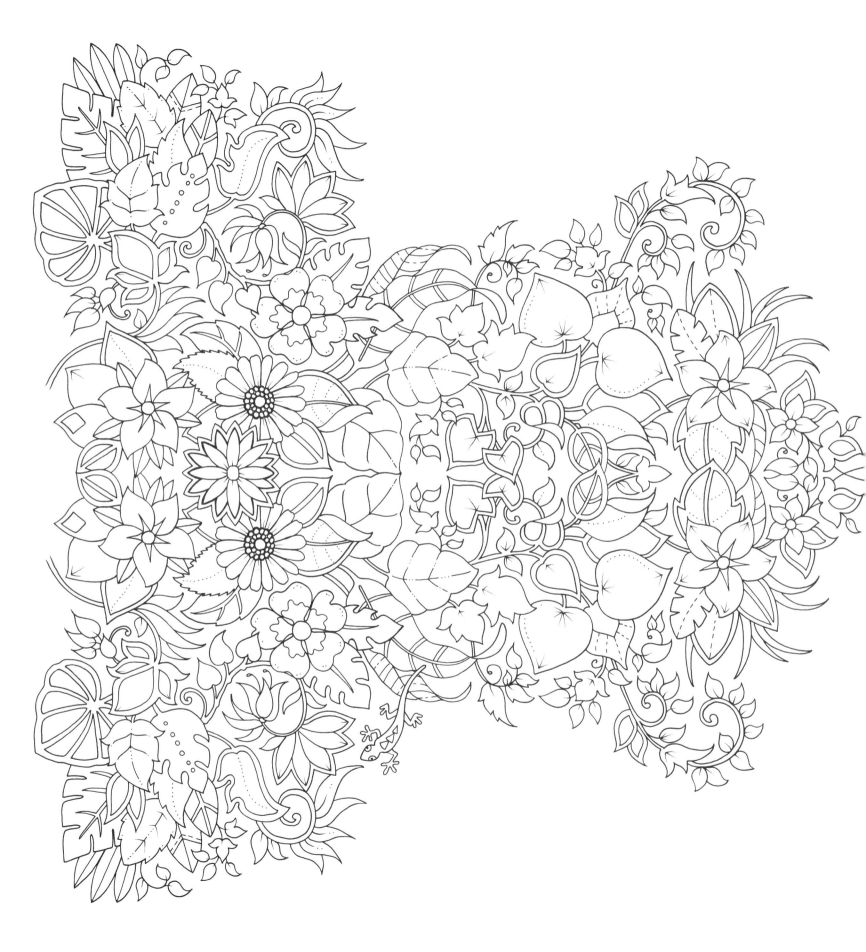

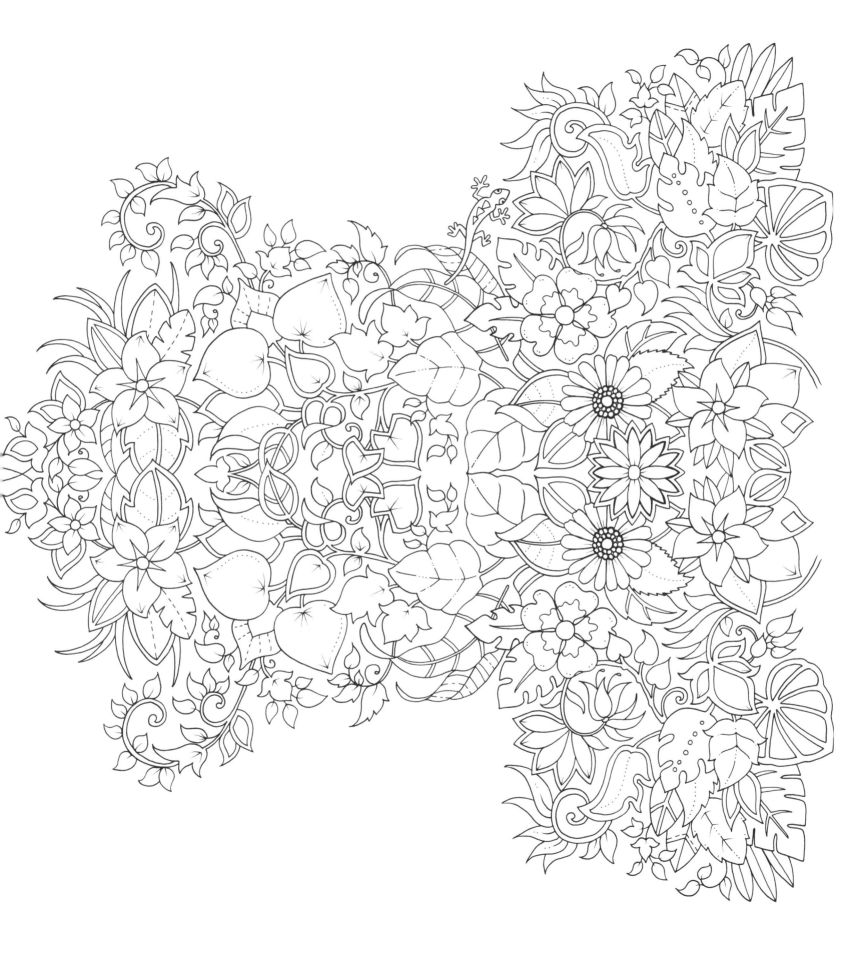

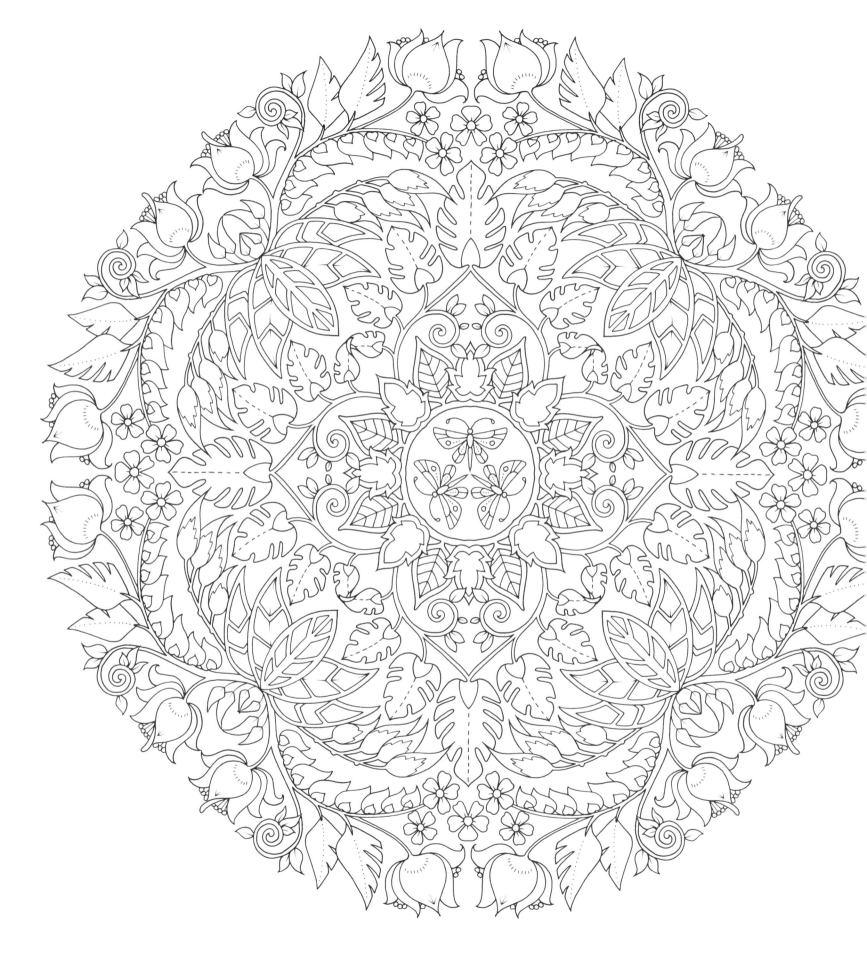

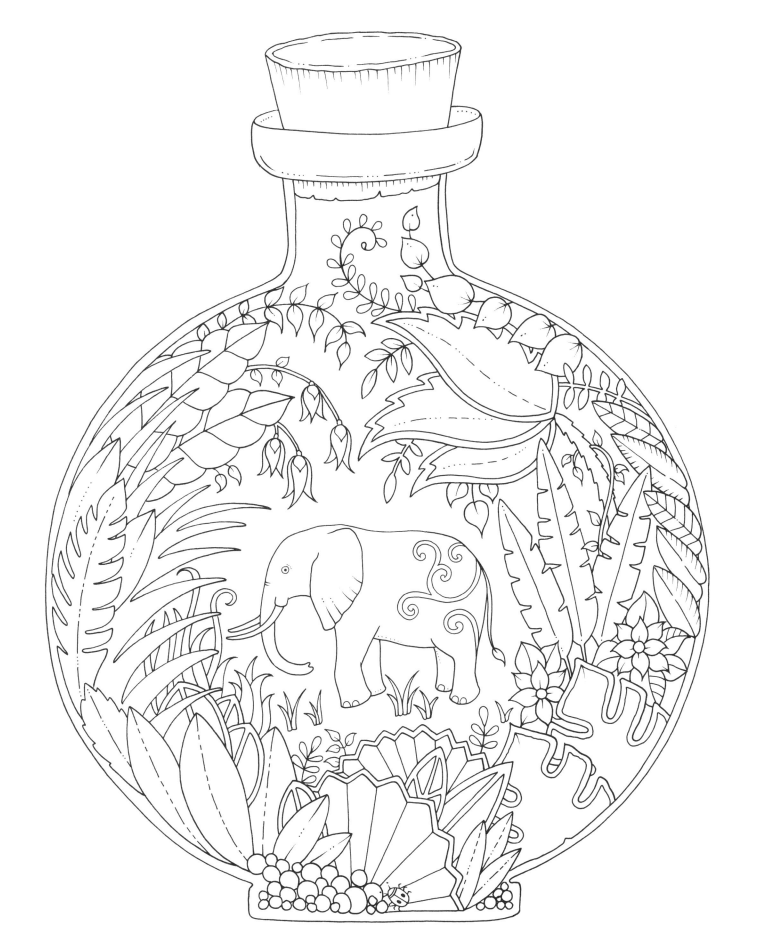

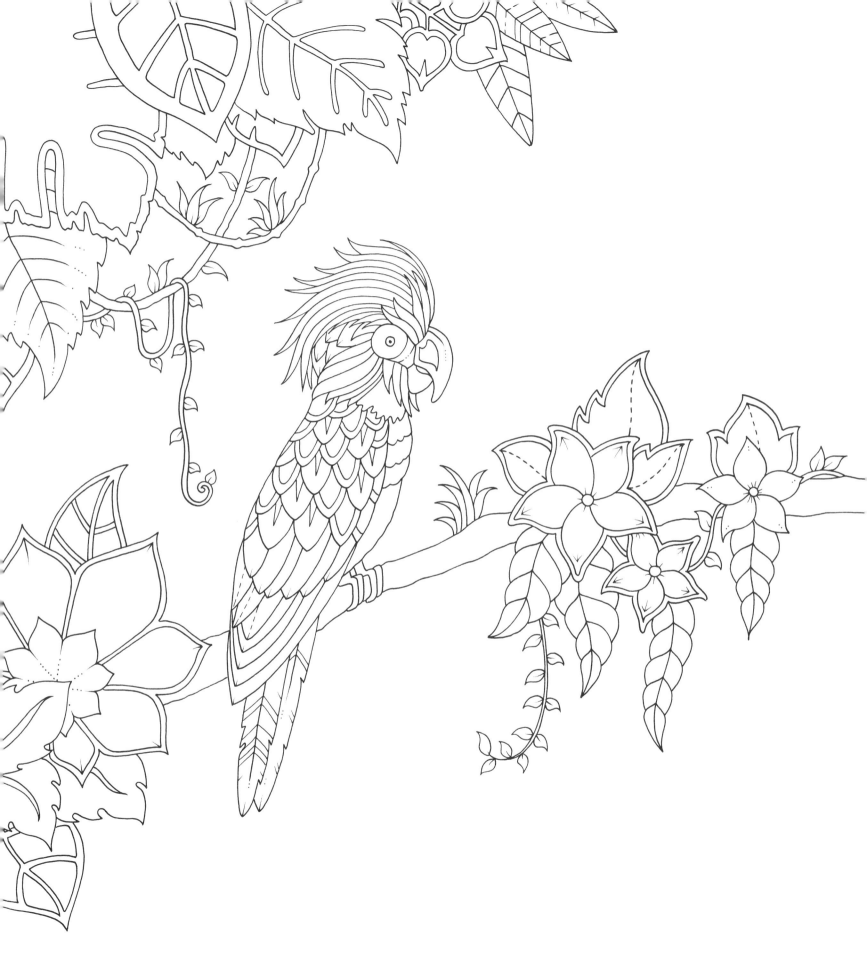

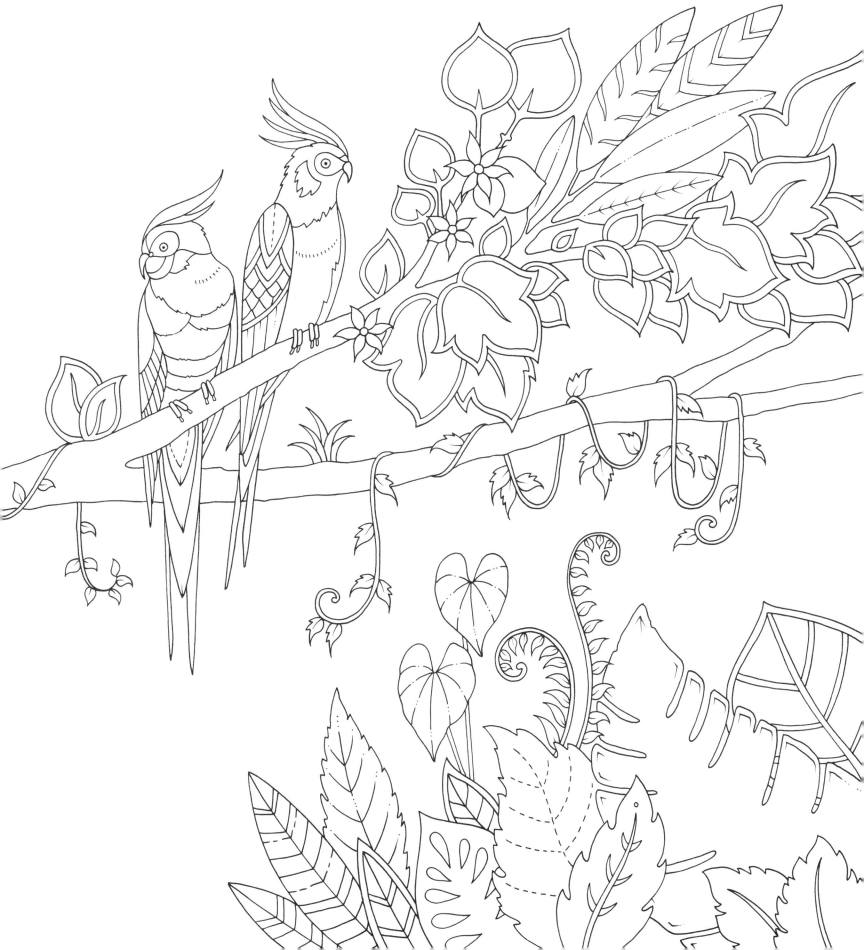

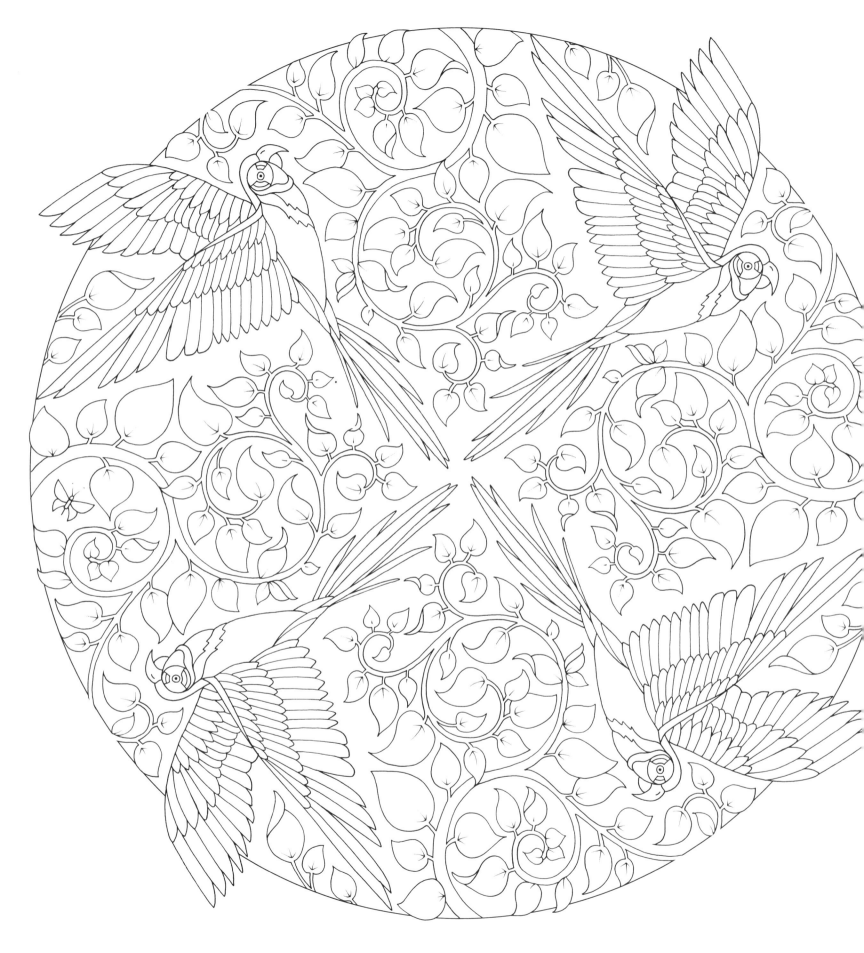

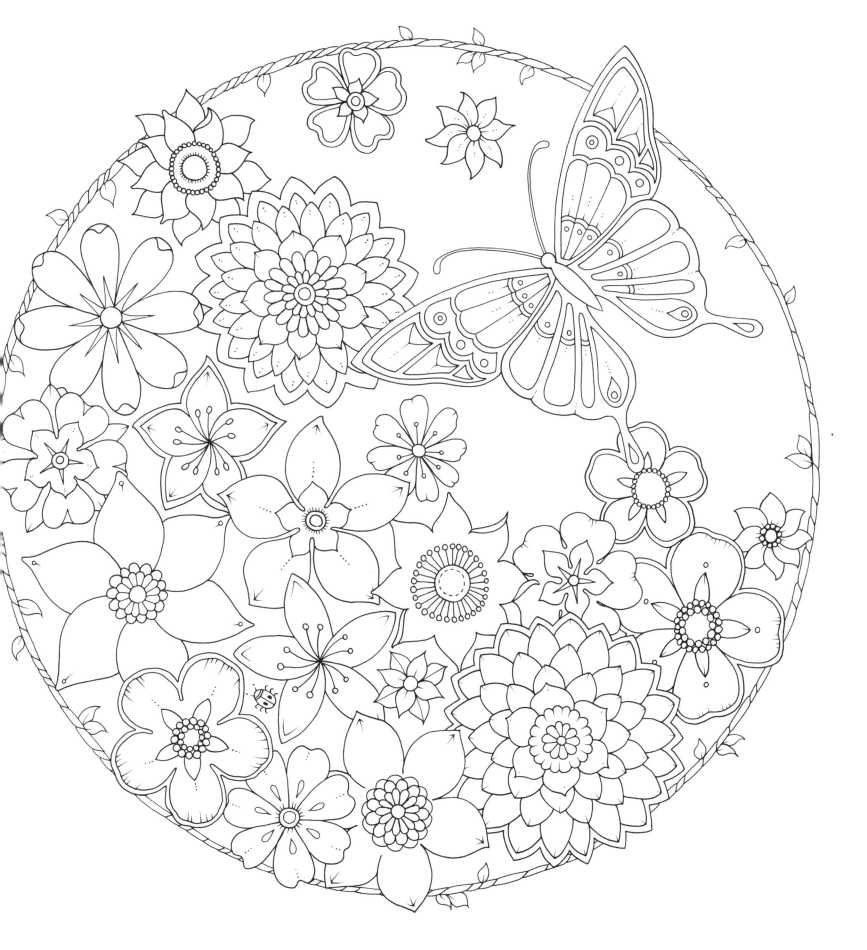

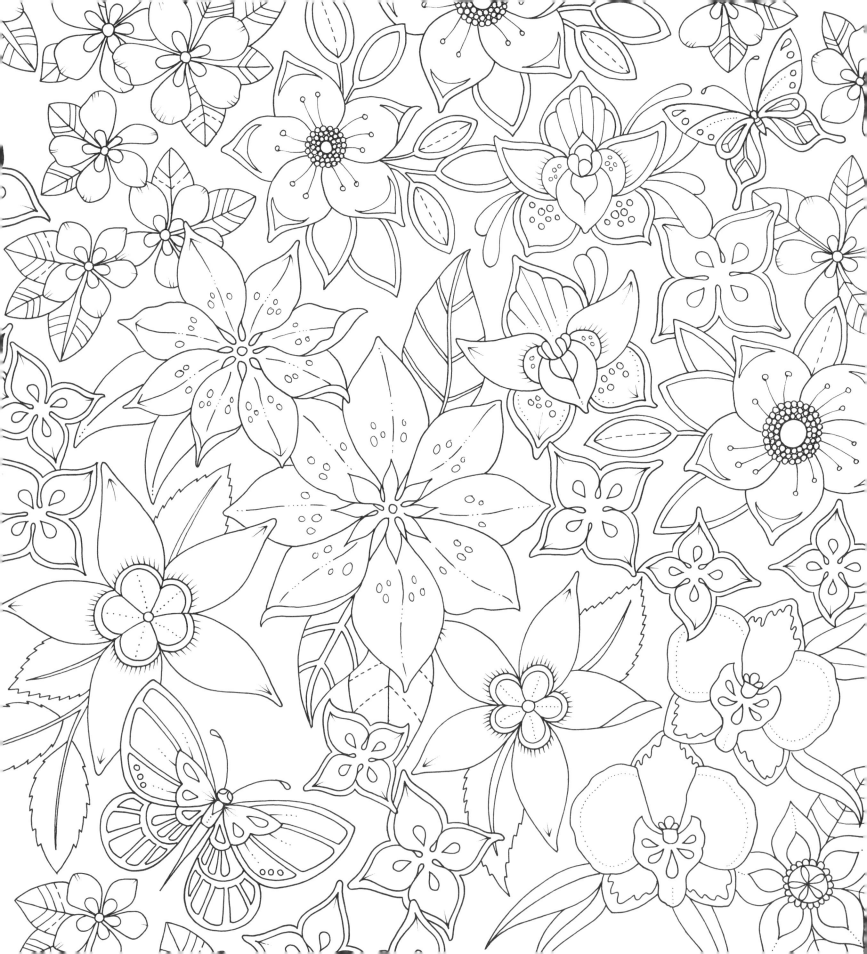

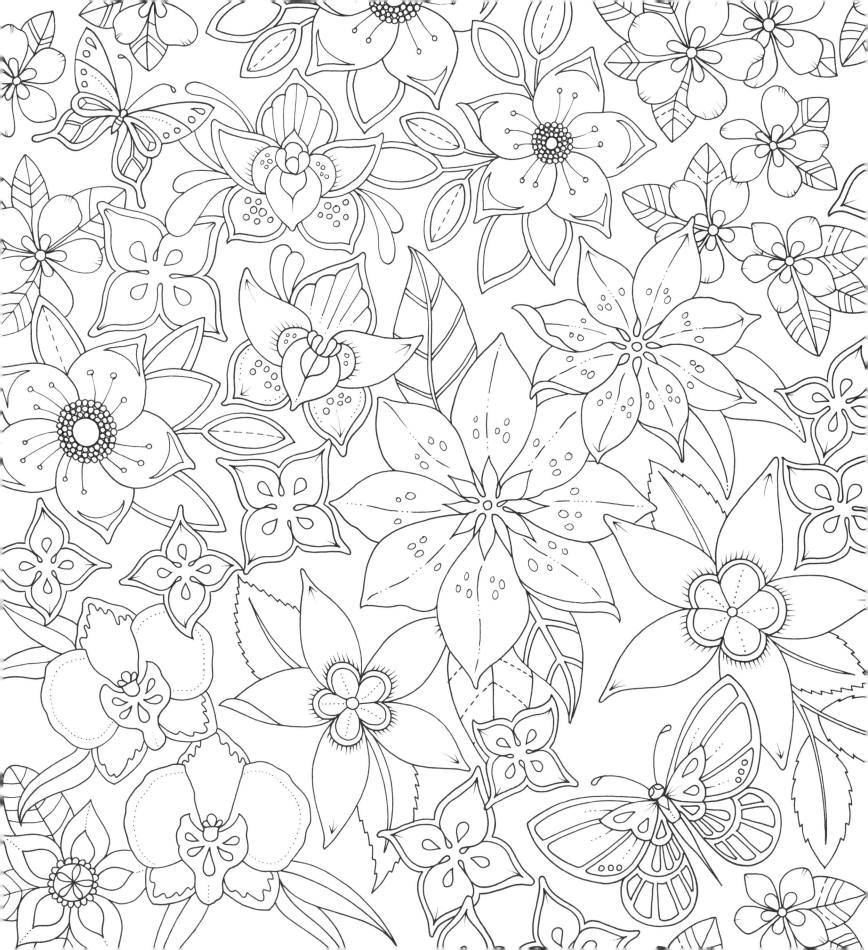

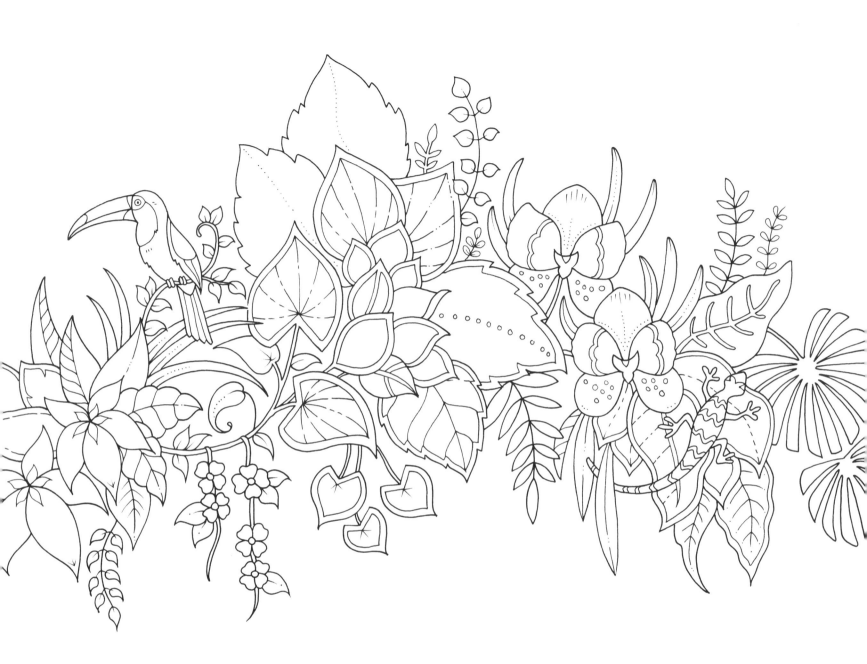

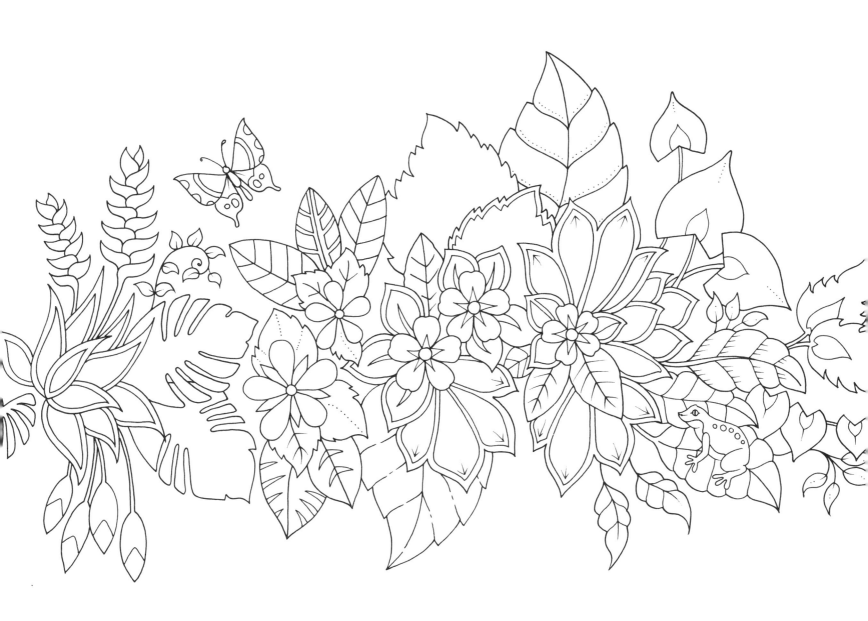

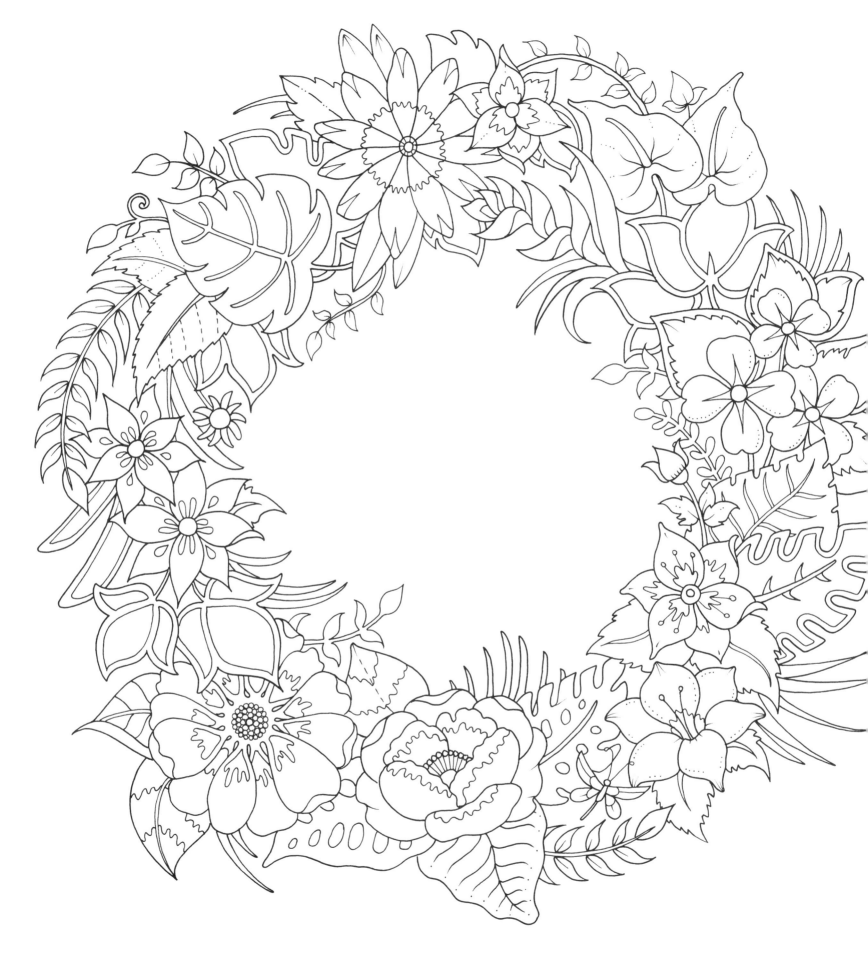

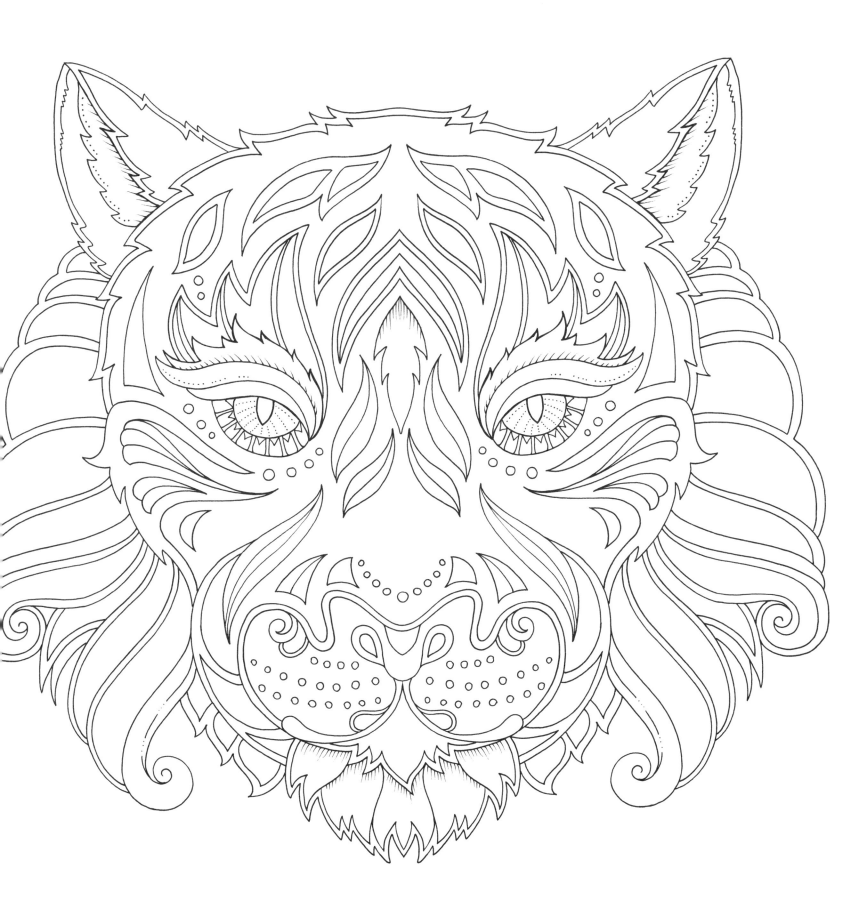

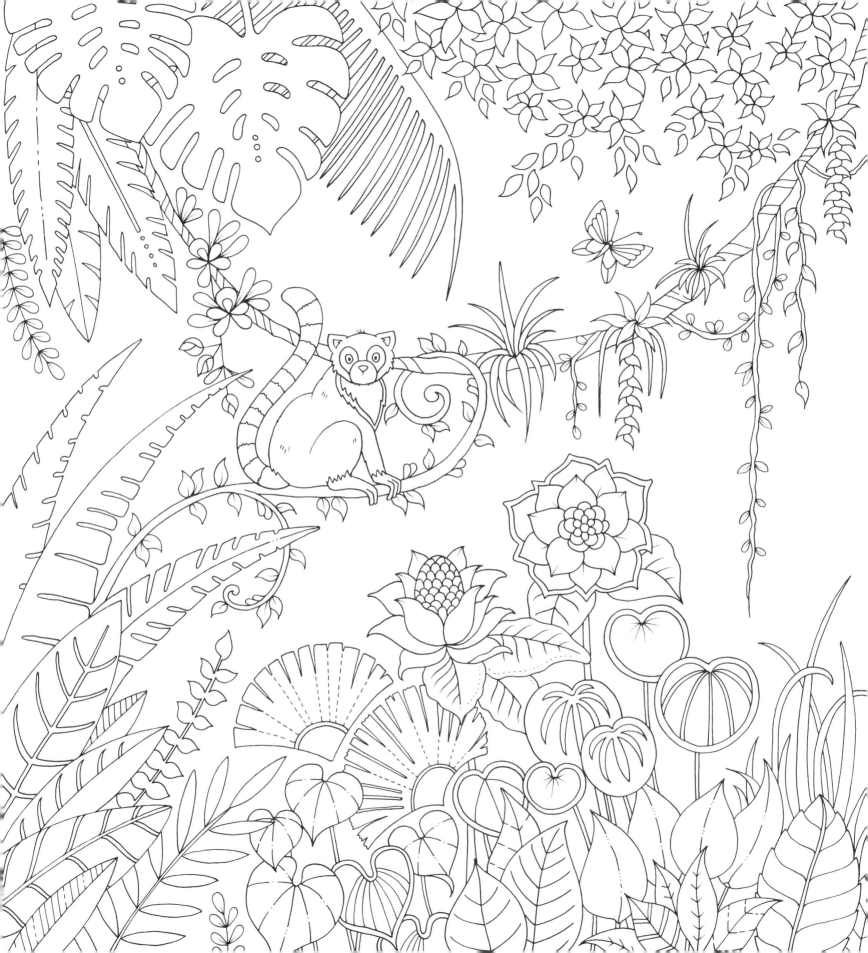

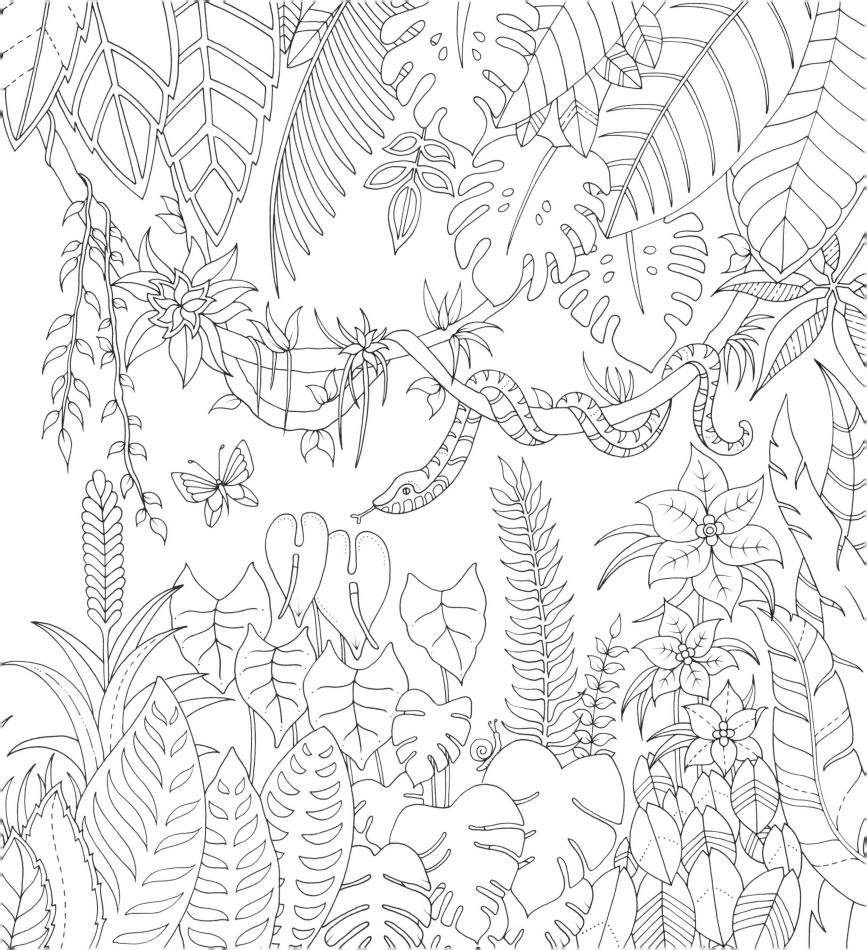

Key to the Magical Jungle . . .
奇幻叢林裡有……

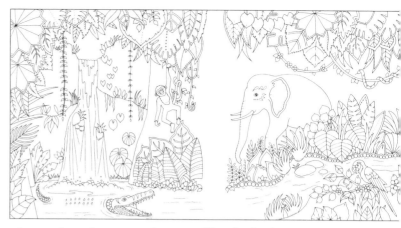

1 monkey, 1 parrot, 1 crocodile, 1 elephant, 1 snake

1隻猴子、1隻鸚鵡、1隻鱷魚、1頭大象、1條蛇

1 monkey, 1 parrot

1隻猴子、1隻鸚鵡

1 butterfly, 1 parrot,
1 dragonfly

1隻蝴蝶、1隻鸚鵡、1隻蜻蜓

2 butterflies, 2 tropical birds

2隻蝴蝶、2隻熱帶鳥

2 hummingbirds

2隻蜂鳥

1 monkey, 3 butterflies, 2 parrots

1隻猴子、3隻蝴蝶、2隻鸚鵡

1 butterfly

1隻蝴蝶

1 butterfly

1隻蝴蝶

butterflies, 1 chameleon, 1 okapi, 1 frog

隻蝴蝶、1隻變色龍、1頭鹿、1隻青蛙

2 butterflies, 1 tiger, 1 snail

2隻蝴蝶、1隻老虎、1條蝸牛

1 butterfly, 1 toucan

1隻蝴蝶、1隻巨嘴鳥

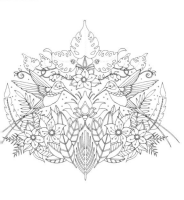

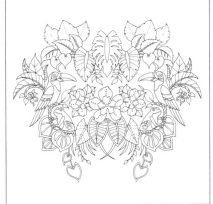

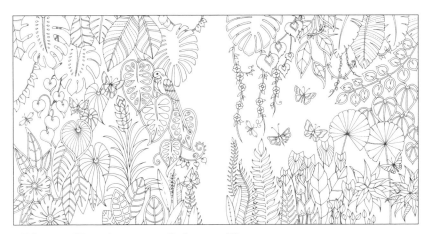

hummingbirds, 2 beetles

隻蜂鳥、2隻甲蟲

2 frogs, 2 toucans

2隻青蛙、2隻巨嘴鳥

7 butterflies, 1 parrot, 2 dragonflies

7隻蝴蝶、1隻鸚鵡、2隻蜻蜓

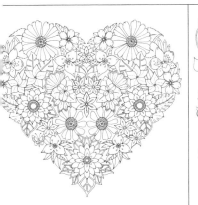

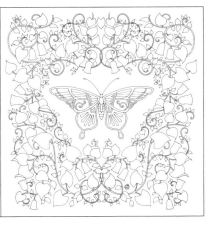

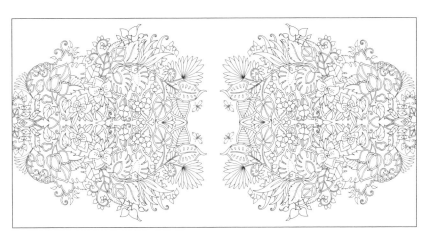

butterfly

隻蝴蝶

1 butterfly, 1 beetle

1隻蝴蝶、1隻甲蟲

4 dragonflies

4隻蜻蜓

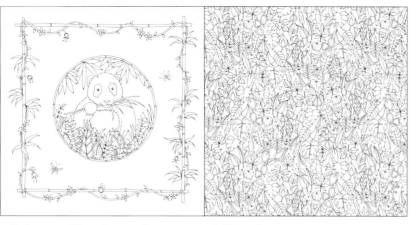 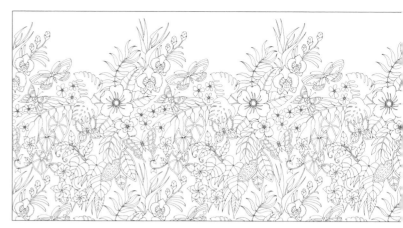

2 dragonflies, 1 panda

2隻蜻蜓、1頭貓熊

1 lizard

1隻蜥蜴

15 butterflies

15隻蝴蝶

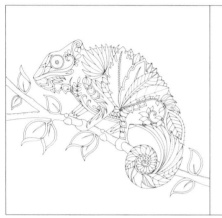 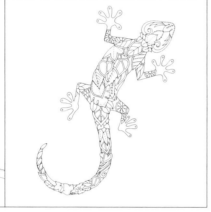

1 chameleon, 1 ant

1隻變色龍、1隻螞蟻

1 lizard, 1 ant

1隻蜥蜴、1隻螞蟻

7 butterflies

7隻蝴蝶

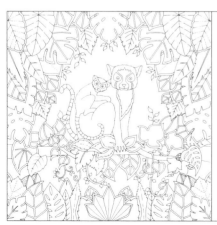 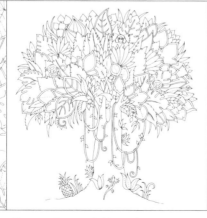 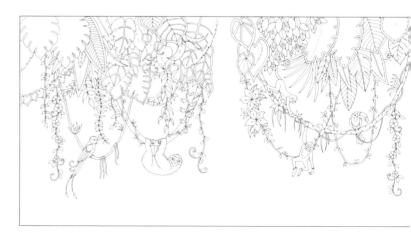

1 snake, 2 lemurs

1條蛇、2隻狐猴

3 monkeys, 1 lizard

3隻猴子、1隻蜥蜴

2 monkeys, 1 tropical bird, 1 toucan, 1 sloth

2隻猴子、1隻熱帶鳥、1隻巨嘴鳥、1隻樹懶

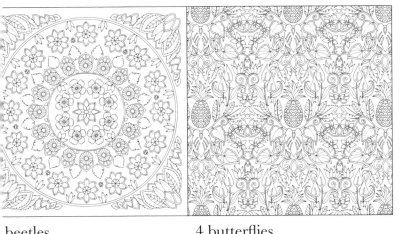

beetles

隻甲蟲

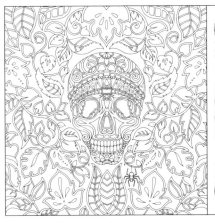

1 spider

1隻蜘蛛

4 butterflies

4隻蝴蝶

1 butterfly, 1 jungle nymph

1隻蝴蝶、1隻叢林若蟲

snail

隻蝸牛

1 monkey, 1 butterfly, 1 snake, 1 frog

1隻猴子、1隻蝴蝶、1條蛇、1隻青蛙

fish, 1 hippo

條魚、1隻河馬

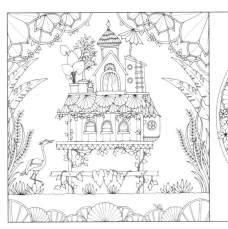

1 snail, 1 stork

1隻蝸牛、1隻鶴

1 frog

1隻青蛙

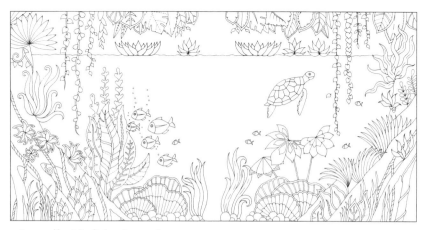

1 snail, 10 fish, 1 turtle

1條蛇、10條魚、1隻烏龜

1 frog, 2 fish

1隻青蛙、2條魚

3 dragonflies, 1 lizard

3隻蜻蜓、1隻蜥蜴

1 butterfly, 2 chameleons

1隻蝴蝶、2隻變色龍

10 parrots, 14 elephants

10隻鸚鵡，14頭大象

2 lizards

2隻蜥蜴

3 butterflies

3隻蝴蝶

1 elephant, 1 beetle

1頭大象、1隻甲蟲

3 tropical birds

3隻熱帶鳥

butterfly, 4 parrots
隻蝴蝶、4隻鸚鵡

1 butterfly, 1 beetle
1隻蝴蝶、1隻甲蟲

4 butterflies
4隻蝴蝶

butterfly, 1 frog, 1 toucan, 1 lizard
隻蝴蝶、1隻青蛙、1隻巨嘴鳥、1隻蜥蜴

1 dragonfly
1隻蜻蜓

1 tiger
1隻老虎

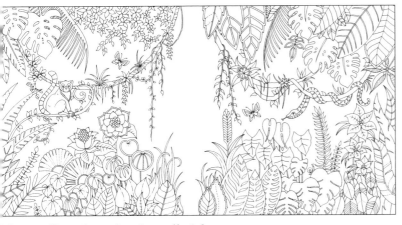

butterflies, 1 snake, 1 snail, 1 lemur
隻蝴蝶、1條蛇、1隻蝸牛、1隻狐猴

Color Palette Test Page

試畫頁

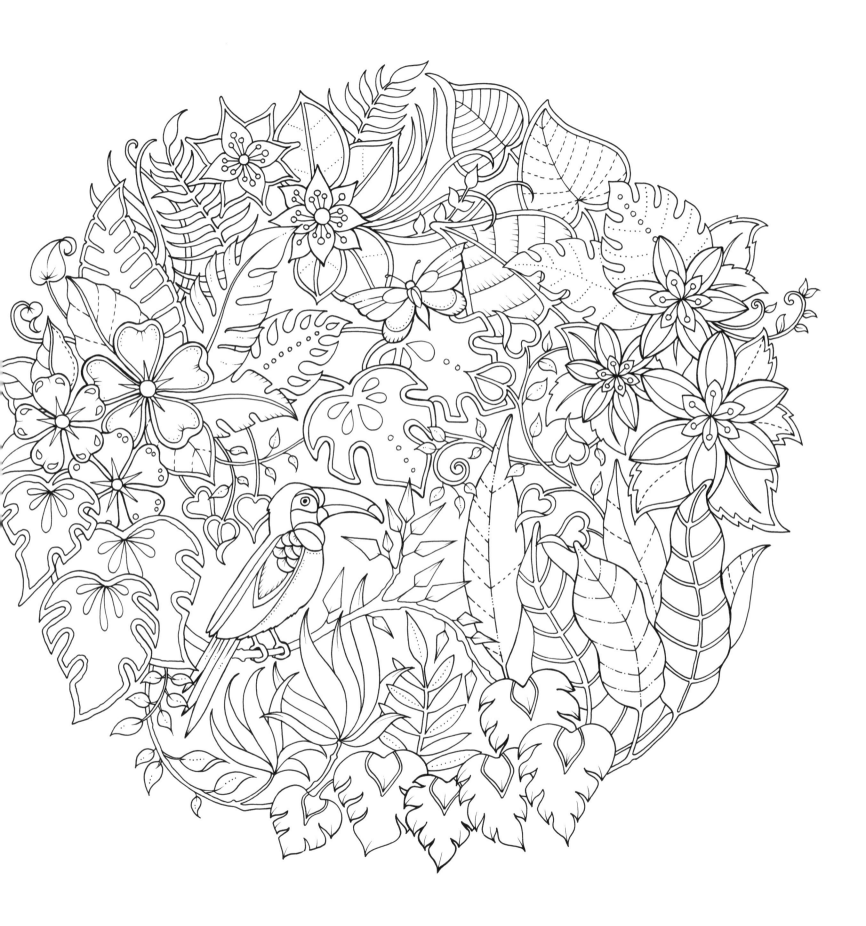

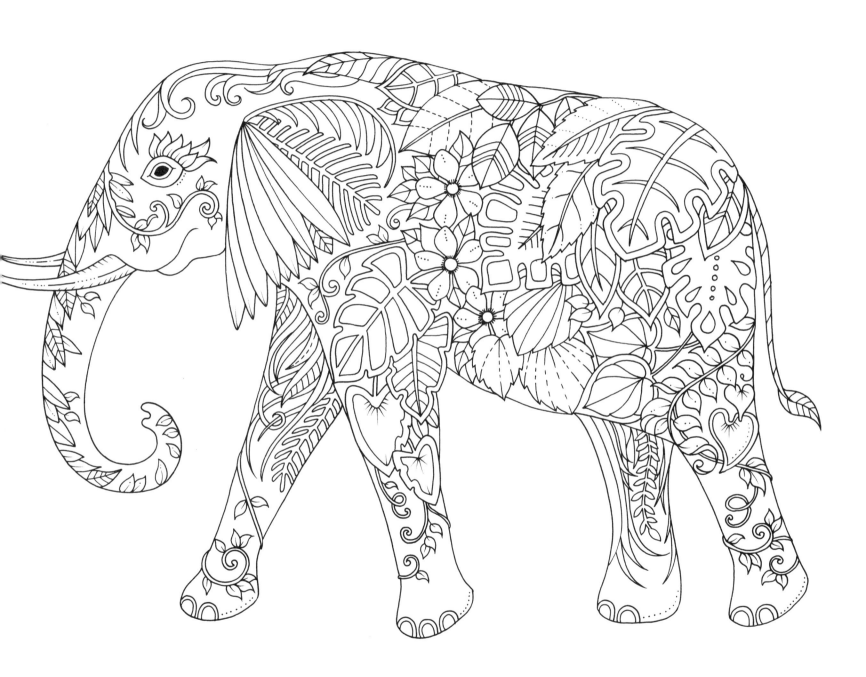

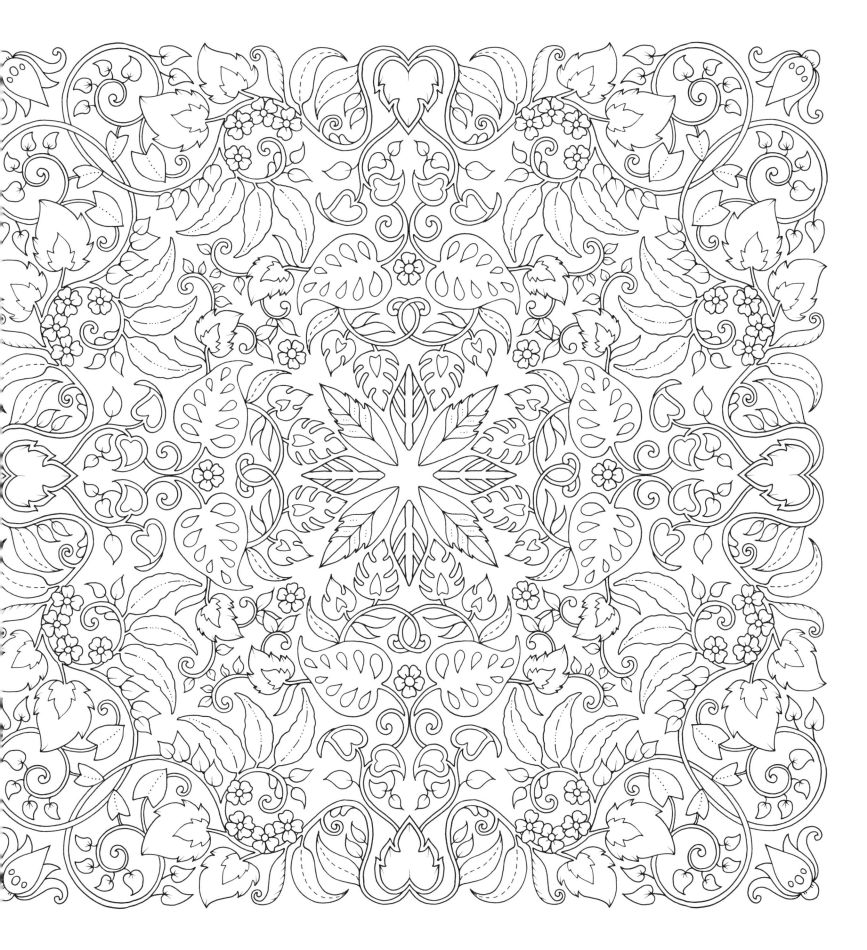

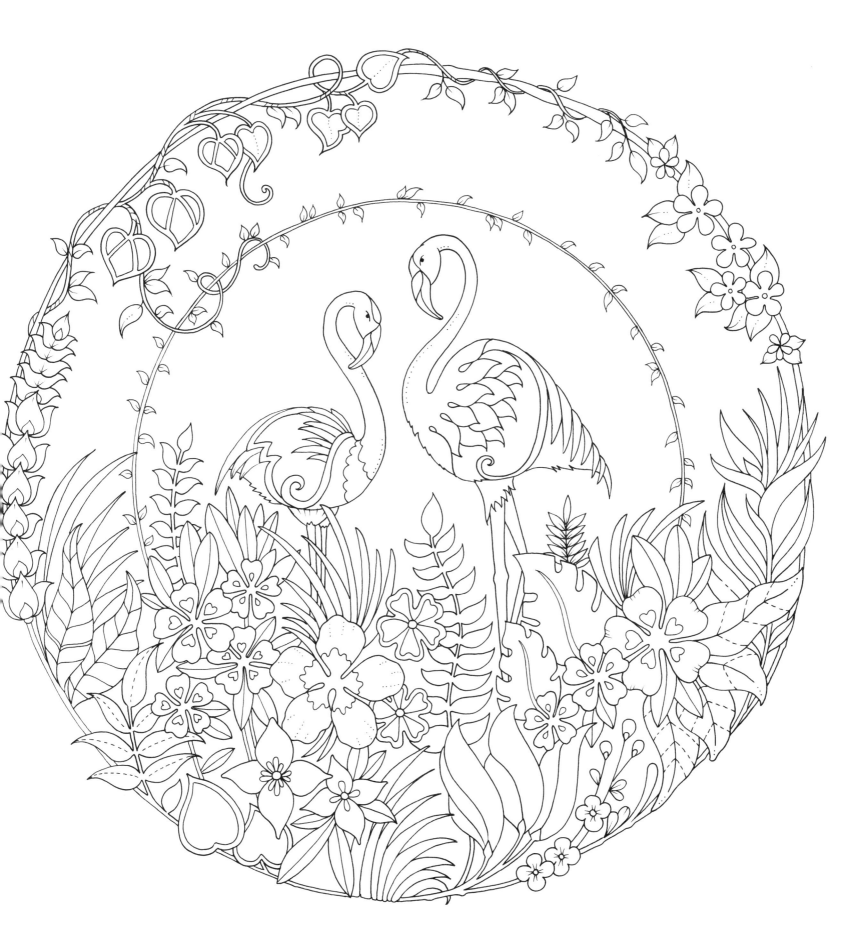